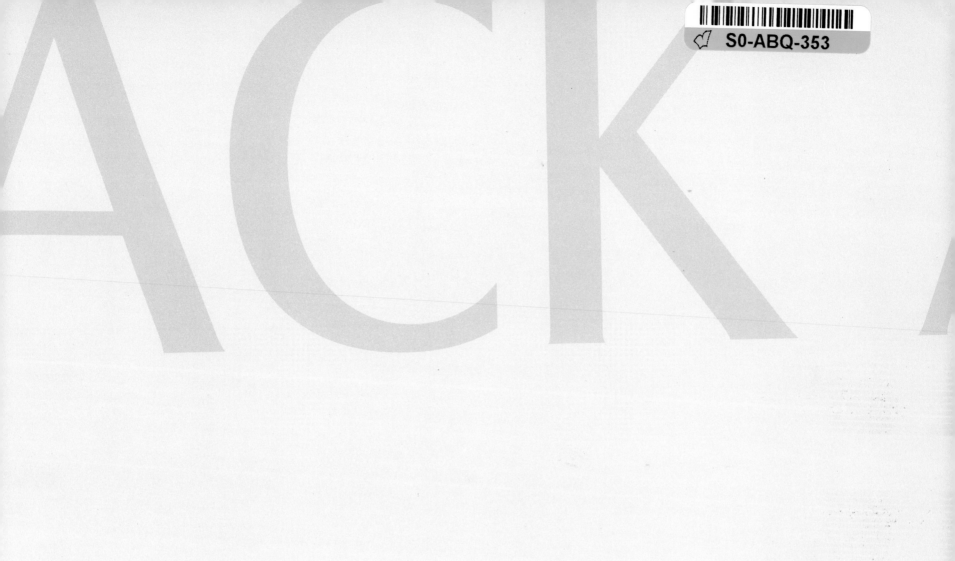

AND

To Marsh Bull
with all my best wishes
Jürgen Schadeberg

Jan. 2006

THE
BLACK AND WHITE FIFTIES
jurgen schadeberg's south africa

The black and white fifties
Jurgen Schadeberg's South Africa

Protea Book House
PO Box 35110
Menlopark 0102
protea@intekom.co.za

© Jurgen Schadeberg
Design: Christian Malherbe
Reproduction: PrePress Images, Pretoria
Printed: ABC Press, Cape Town

First edition, first print, 2001

ISBN 1-919825-71-1

My great thanks to the following people
for making this book a reality:

Nicol Stassen; Christian Malherbe;
Patrick de Mervelec; Jean Bourdin ...
and of course all the people I had the
privilege of photographing.

I dedicate this book to my wife Claudia who has been my inspiration and who

has encouraged me for the last two decades to continue with my work related to South African history.

Without her continuous, active involvement I would have given up long ago.

INTRODUCTION

When I arrived in South Africa in 1950 from Germany I found two societies running parallel, without any communication whatsoever. There was an invisible wall between the two worlds. The black world or the "Non-European World", as described by white society, was culturally and economically rejected by the white world.

In the fifties the black world was becoming culturally and politically very dynamic, whereas the white world seemed to me to be isolated, cocooned, colonial and ignorant of the black world.

As a newcomer and outsider I managed quite easily to hop from one world to the other ... for example, in the evening I might photograph a white masked ball in the City Hall, the next morning an ANC Defiance Campaign meeting, or a shebeen in Sophiatown ... all followed by the Durban July horse race. On both sides of the fence there were ordinary people living their lives, getting married, enjoying themselves, making music and dancing. Most people were ignorant of one another's worlds despite the fact that they were neighbours, sharing the same air.

The political campaigns against apartheid laws in the early fifties were largely peaceful with an almost gentlemanly attitude between the government officials or Special Branch police and the political demonstrators. On one occasion a speaker standing on the platform at a political meeting even stopped his speech so that the Special Branch could reload his tape recorder. It was only in the late fifties and early sixties that clashes became more violent and more brutal.

I freelanced for a number of magazines and photo agencies during the fifties decade, including Drum, Time Life and the SABC Radio, as well as selling my photos to German, French and American publications.

We all believed that the apartheid government would not last, which, in a way, explains the naïve enthusiasm which I think is portrayed in many of my pictures.

Jurgen Schadeberg

PREFACE

Jurgen Schadeberg wrenches moments and people right out of time, place and mood, so that we can engage with them here and now, as we are, at the instant of looking. We gasp and feel a frisson of delight at each picture. Was it really like that? Look at the faces as they were then, the hairstyles, the clothes people wore, the way they looked at each other. What is still the same, what has changed?

There is the honesty of values, the dignified and respectful treatment of the subject matter and especially the people who might be involved. In this respect Jurgen's photographs are extraordinarily sensitive. He arrived in South Africa during a difficult period in our history when the laws and the practices of the state denied humanity to the majority of the population and encouraged the minority to deny its own humanity. Yet these are photographs of annunciation, not of denunciation. They capture the joy and vitality of people from the oppressed community who had confidence that a new and more beautiful world would emerge one day. By showing them affirming their humanity and vitality, he did more to denounce oppression than if he had simply depicted them as victims of injustice. And the whites, trapped in their restricted colonial styles, are also treated with quiet respect, anticipating the day when they would irreversibly, even if reluctantly, accept that they were no longer destined to rule over others. Jurgen had a great advantage over South African photographers – he was not part of the scene he was recording. He came with a clear perspective. He emerged from the ruined city of Berlin with a sense of innovation and joy at being alive and creative. He did not

manipulate the people he photographed to prove a point, but rather, he allowed them to affirm themselves in moments of intense expressivity. Just as he showed respect for the subjects then, so does he manifest respect for the viewers today. He is not seeking to pass off to us concocted or manufactured images to correspond to and confirm stereotypes. On the contrary, he allows authentic moments of human activity and expression to speak to us in a direct and relatively unmediated way. Thus, the pictures in this volume respect the dignity of the readers through respecting the dignity of the subjects. Jurgen clearly loves and respects the craft of taking and reproducing images. In fact, his stories are not about technique; technique is subordinated to and immersed in the stories. He relies not on the artificial highlights and shadows of studio portraits, but on the soft and ambiguous light of the ephemeral world around us, or the hard-edged glitter of the dance floor. He does not use stratagems to get the stories to say more than they comfortably say themselves. The result is images that are the more compelling because of their very ease, their lack of strain. The person, the photographer, the people, the images, the book, there is a spontaneous and loving relationship between all of them. Thank you, Jurgen, for coming to South Africa as a naïve and artful young man. And thank you, Jurgen, for sharing with us, as a naïve and artful older person, these lovely images of a world that is slowly but truly coming true.

Justice Albie Sachs September 2001

The Ritz, downtown Jo'burg, was the place to go for a jive come Friday night. There was good music and the hall was jam packed with people who jumped for joy. Then one night in December '51 a gun went off, there were shouts and screams and lots of smoke and the place burnt to ashes.

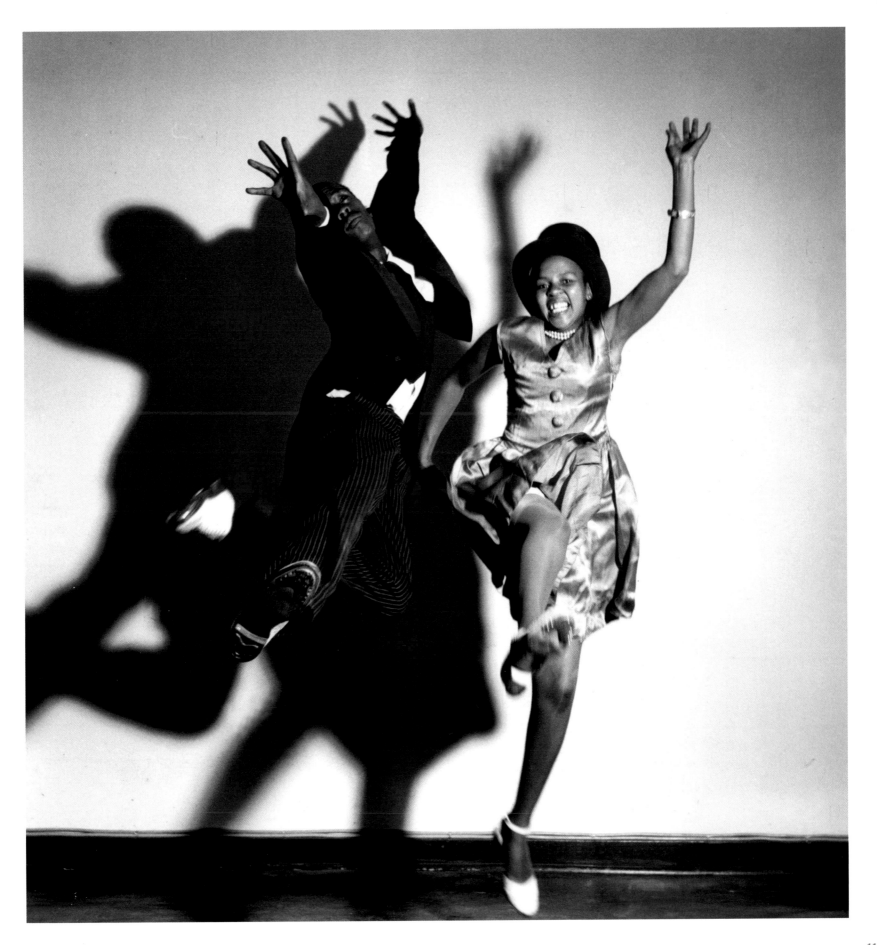

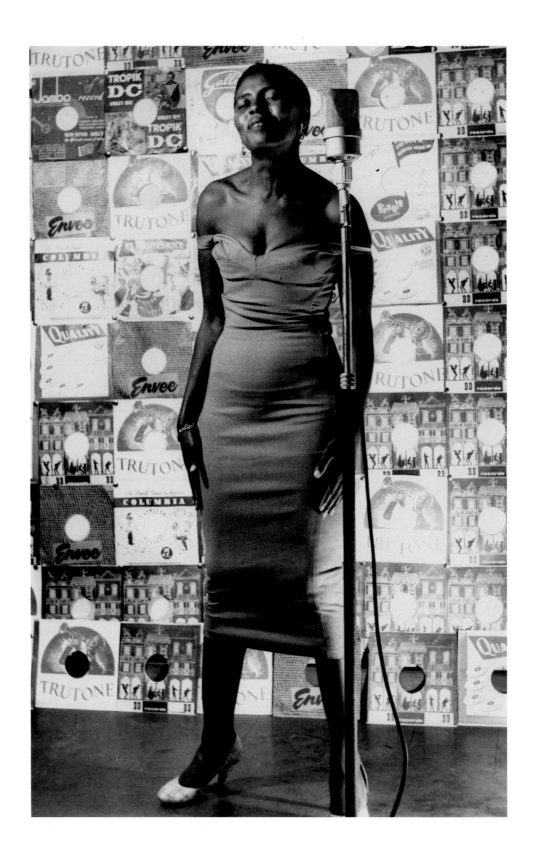

One night at The Ritz Nathan Mdledle (right), leader of The Manhattan Brothers, came up to Miriam Makeba (above) and said, "I like the way you carry a tune," and asked her to join the group and they never looked back. Nathan "Dam-Dam" Mdledle was the composer, arranger and mastermind of The Manhattan Brothers.

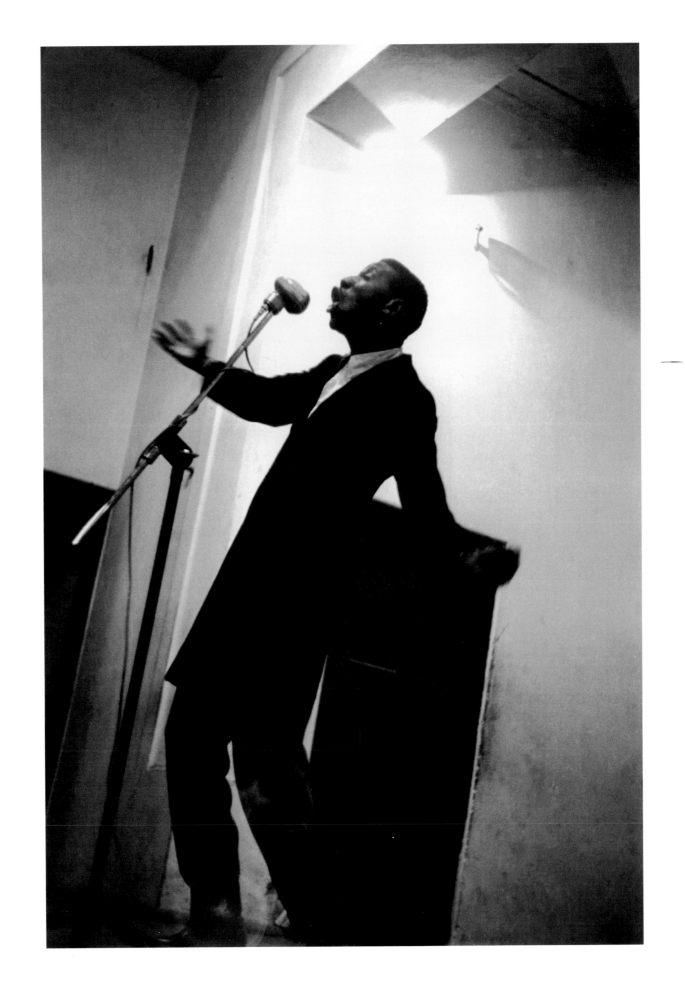

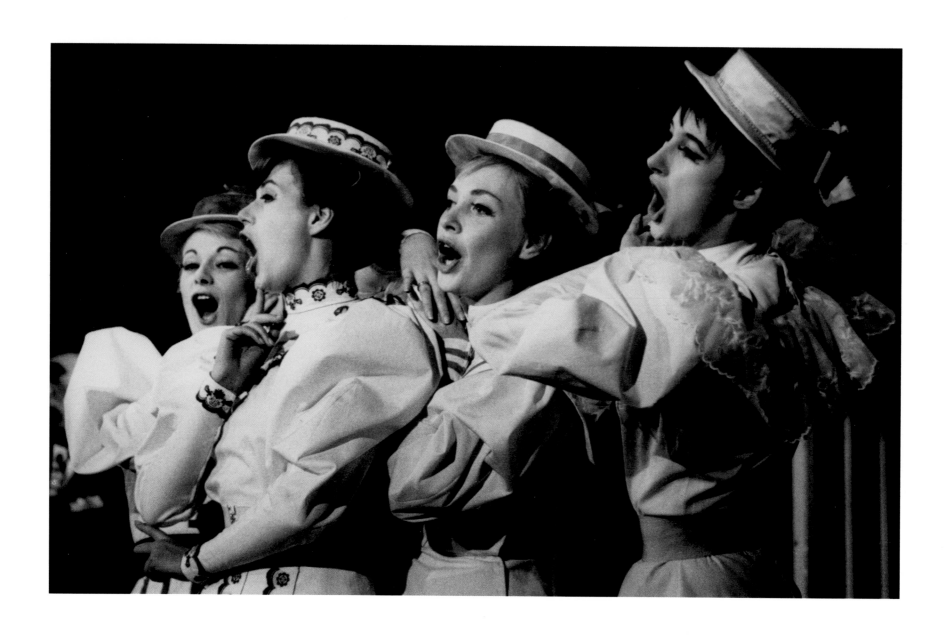

A musical show at the Colosseum where they sang and danced (above).
At a pool in the Northern Suburbs. They jumped and skipped, directed by Ronald Arden, who was rehearsing them for a play (right).

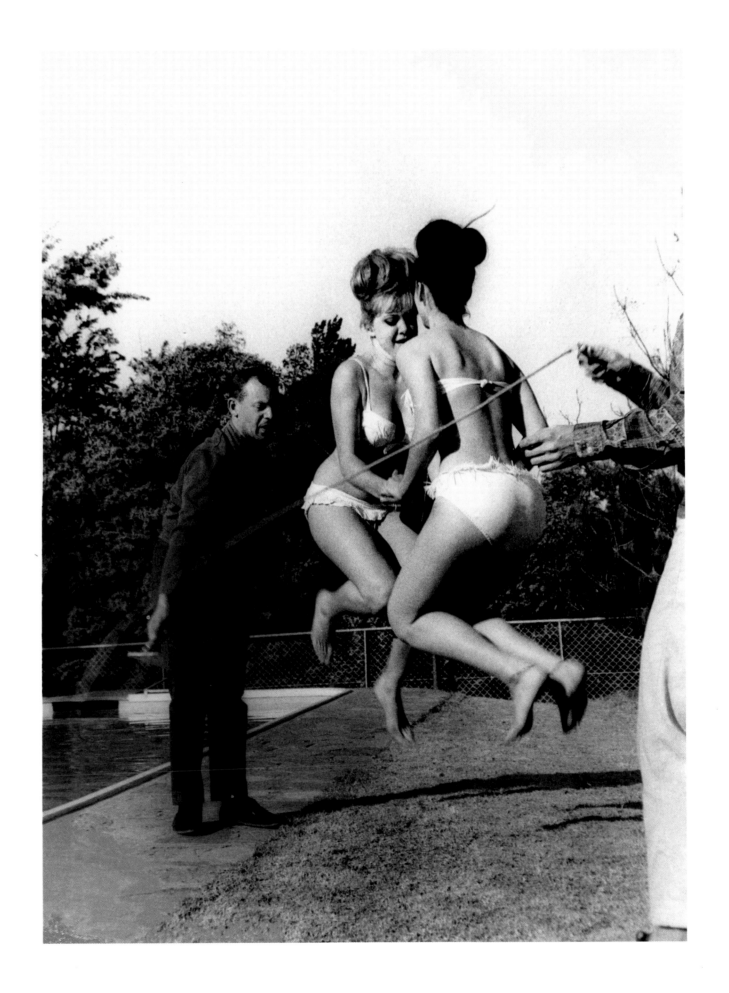

Benni Benjo "Gwigza" of Mrwebi also known as Gwigwi, clarinet, alto sax player, bandleader, clown and showman. Gwigwi was leader of the Harlem Swingsters in the 1950s. Name a stage, he was on it. Name a show, he was in it, playing his clarinet and his alto sax. He played highbrow and lowbrow with equal zest.

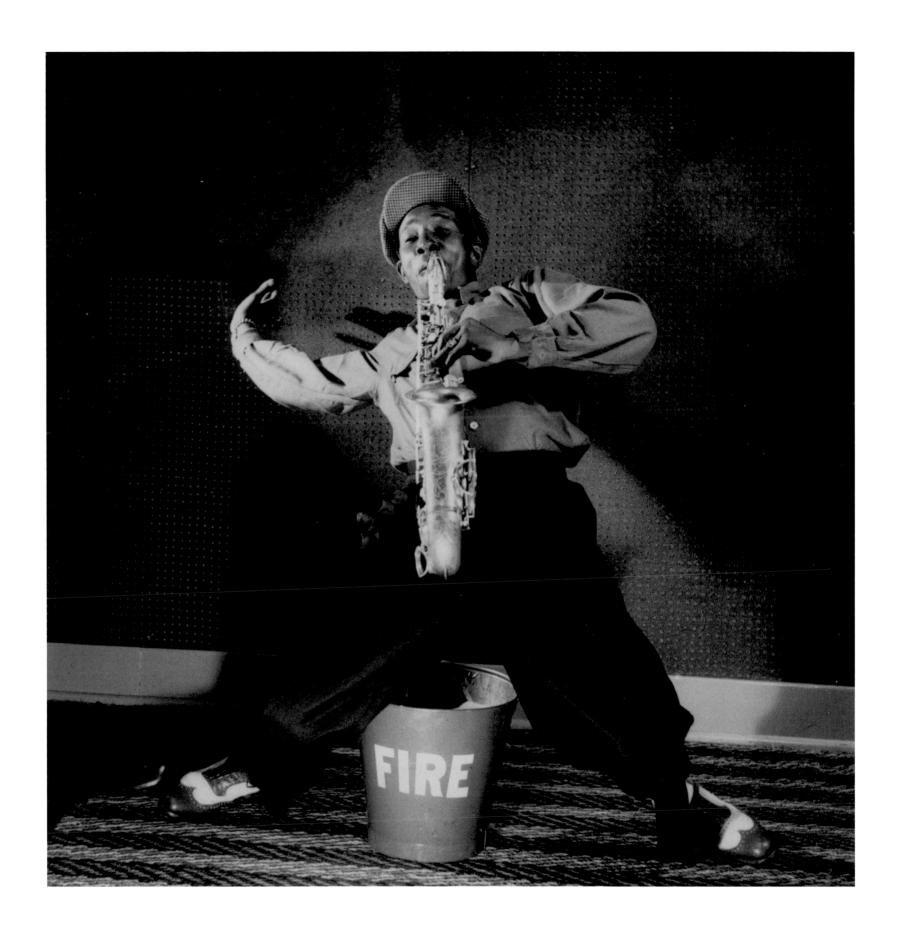

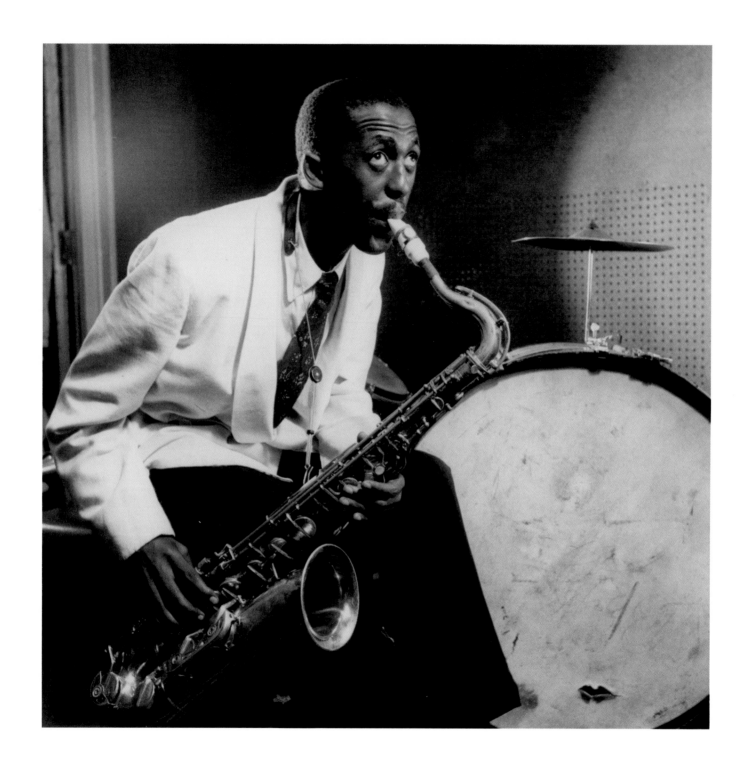

Edmund "Ntemi" Piliso. It was said that when Ntemi picks up his tenor horn other tenor men start searching for ideas. In the fifties he formed his own hot "Alexandra All Star Band" (above).
Ideas came from Harlem and New Orleans … there was Lena Horn, Satchmo, The American Inkspots, The Mills Brothers … that the South Africans adapted, adding their unique African flavour (right).

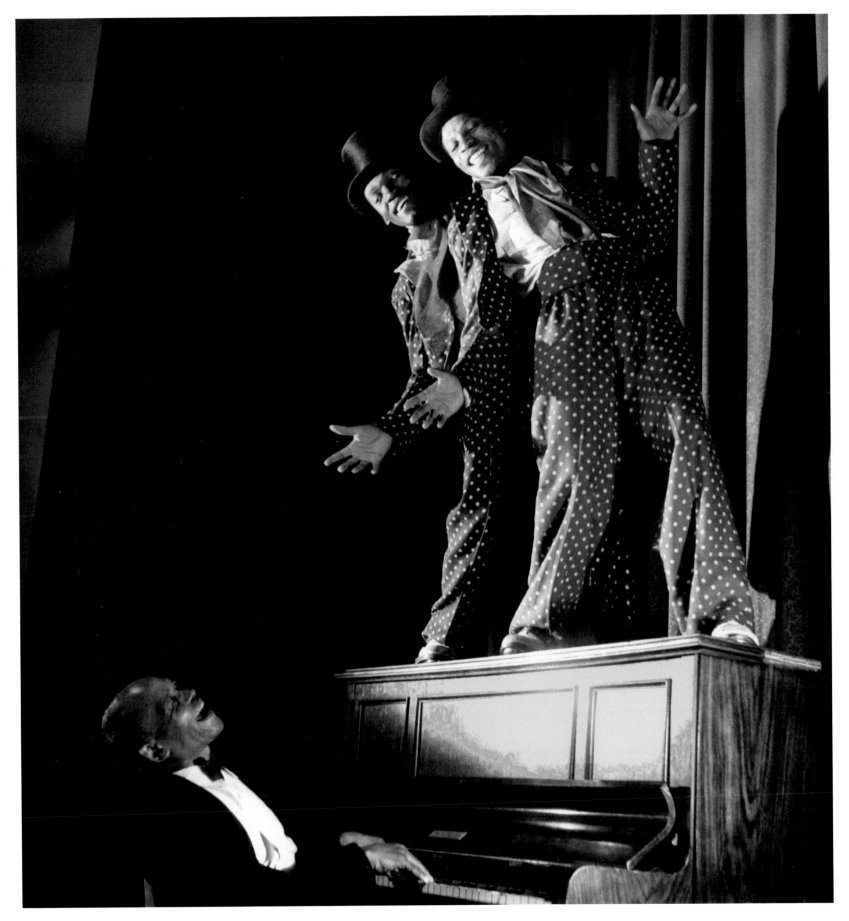

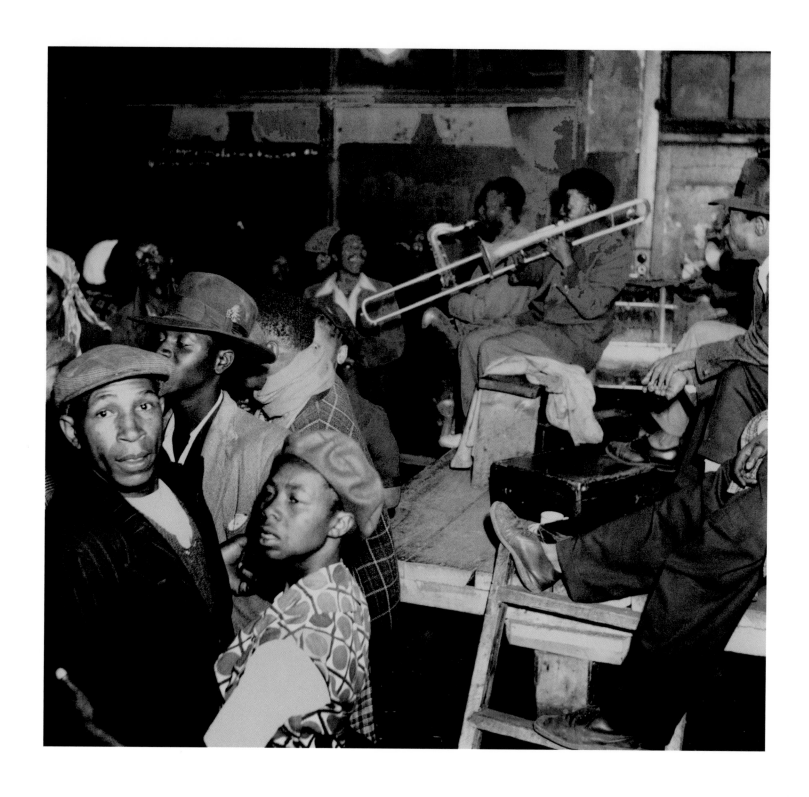

There were dance halls everywhere, from Orlando to Mamelodi to Sophiatown … the stages were often improvised and there was real sound, without microphones and amplifiers. Couples were swinging away in cool and slow rhythms.

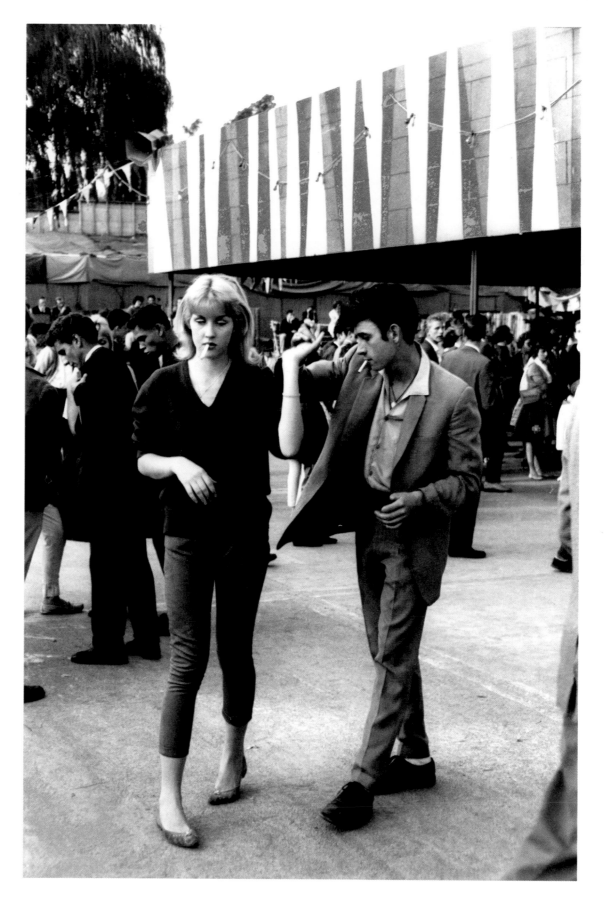

The shuffling "Ducktails" arrive at the Rand Easter Show.

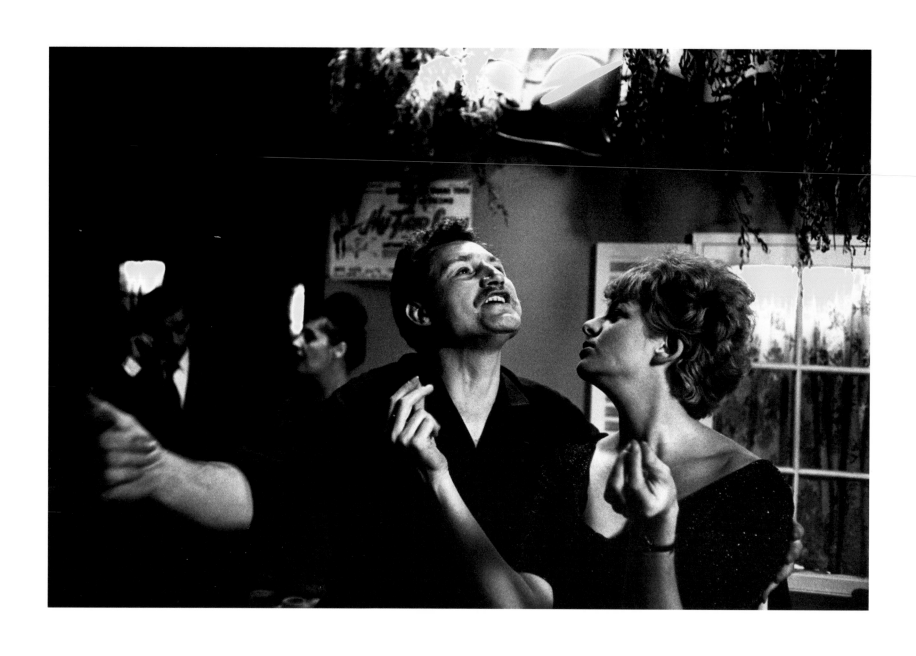

The "Gay Gaieties" (right) sang and danced in the dance halls along the reef, all five of them loved by all.
Actress Jenny Gartus (above) doing a Greek number accompanied by Sasha and Retsina in one of many Greek tavernas in downtown Jo'burg.

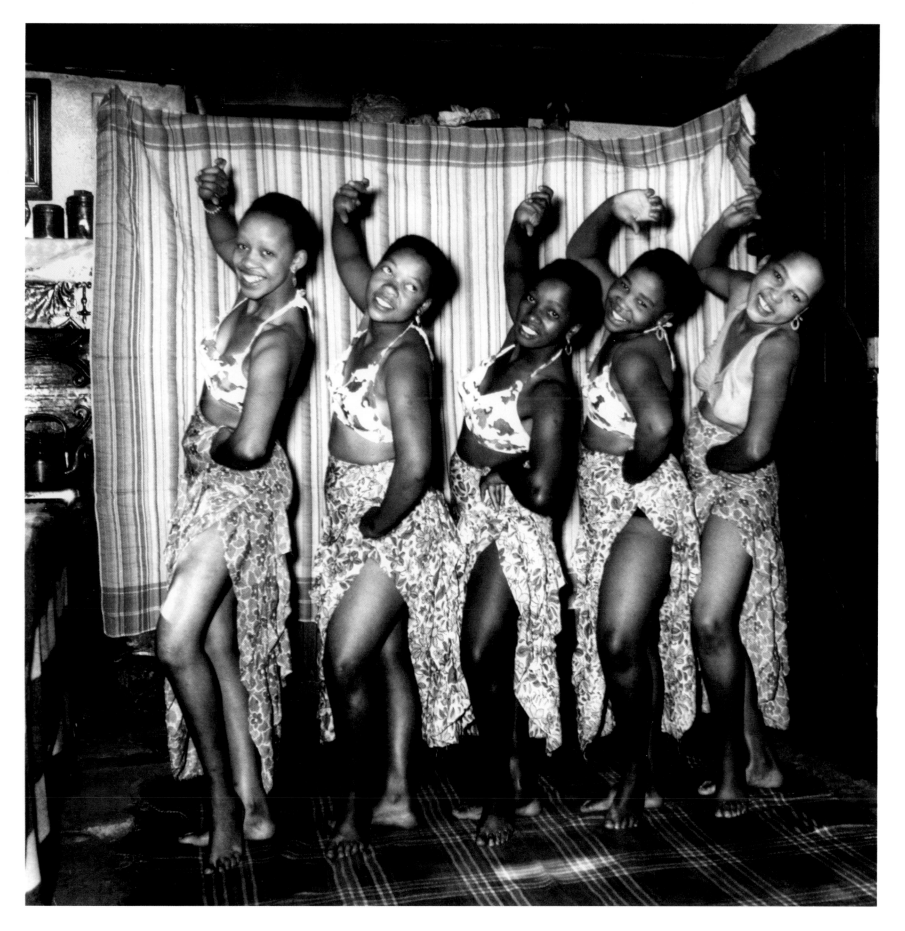

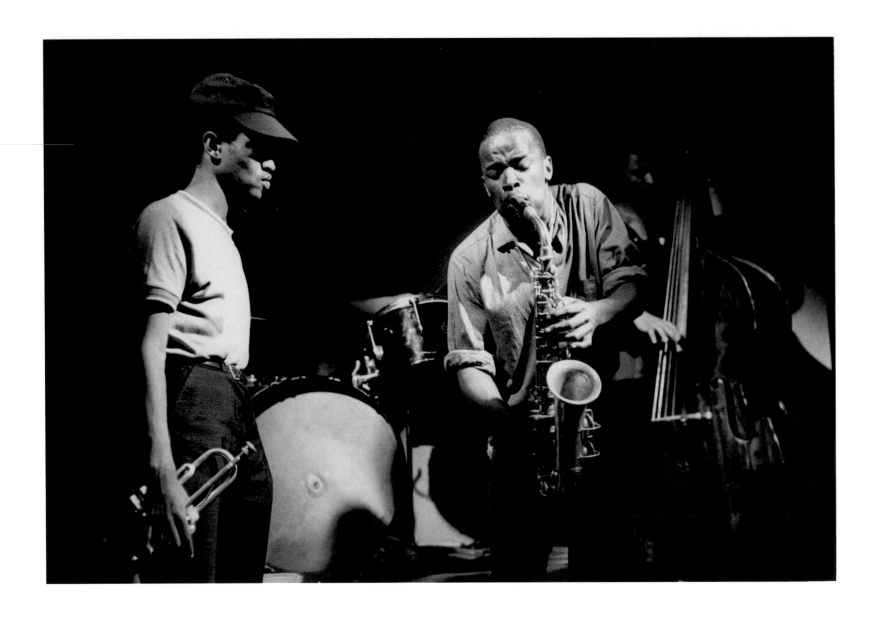

In the high-rise flatlands of Hillbrow in Johannesburg, Mongesi "Monks" Feza (left) and Dudu Pukwana jazzed away in a smoky basement jazz club to swinging and toe tapping enthusiasts.

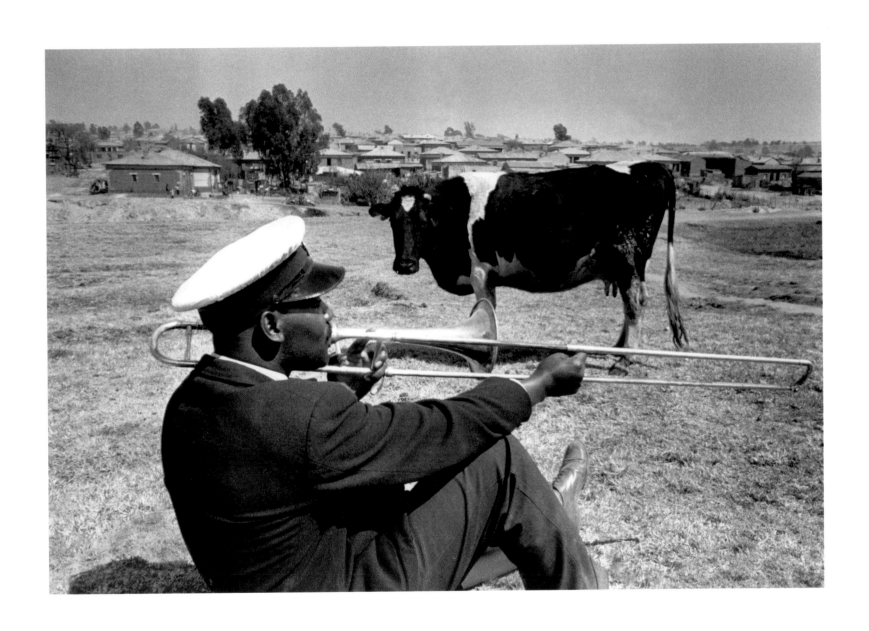

Alexandra, a township north of Jo'burg, is surrounded by open country and farms where cows were often entertained by lonely brass band players rehearsing a tune.

The three Jazzolomos: Jacob "Mzala" Iepers (bass), Ben "Gwigwi" Mrwebi (alto sax), Sol "Beegeepee" Klaaste (piano). "We three, the Jazzdizzlers be. Non-stop eight to four am, that's what makes us such dazzling dizzlers in the jazz business. Ragtime, swing, jazz bop. An occasional gunshot whiz bang 'gainst the wall behind you – till four am."

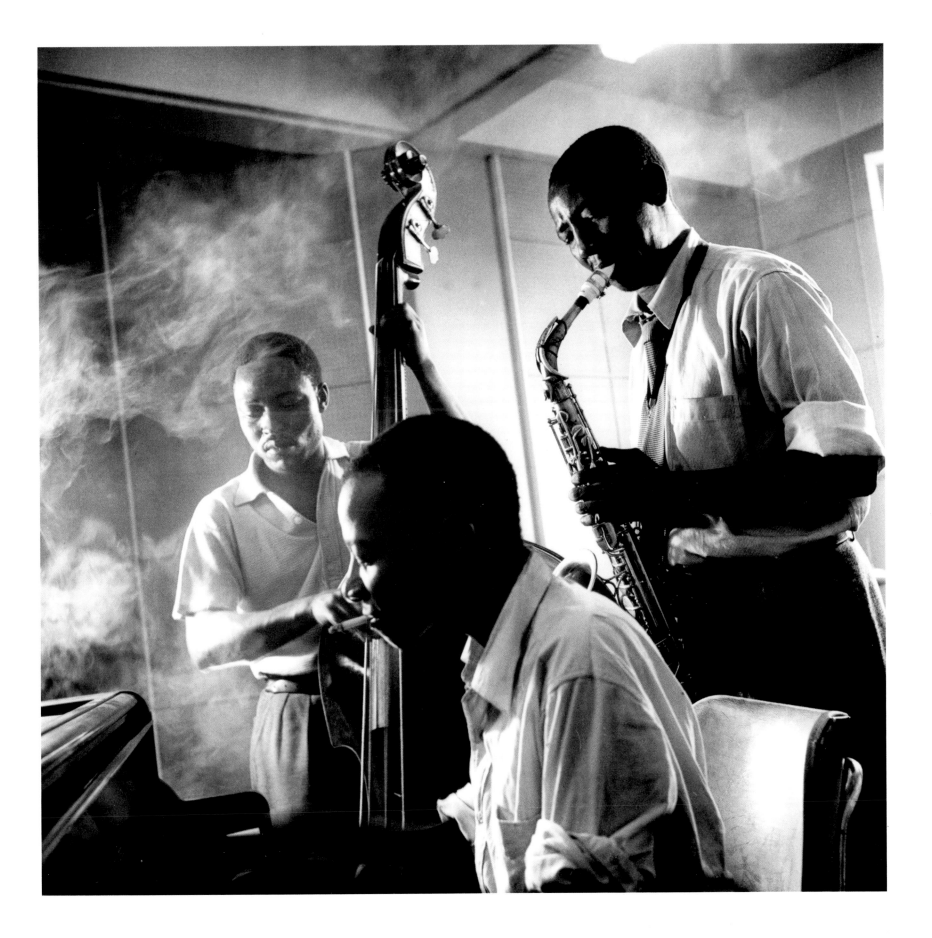

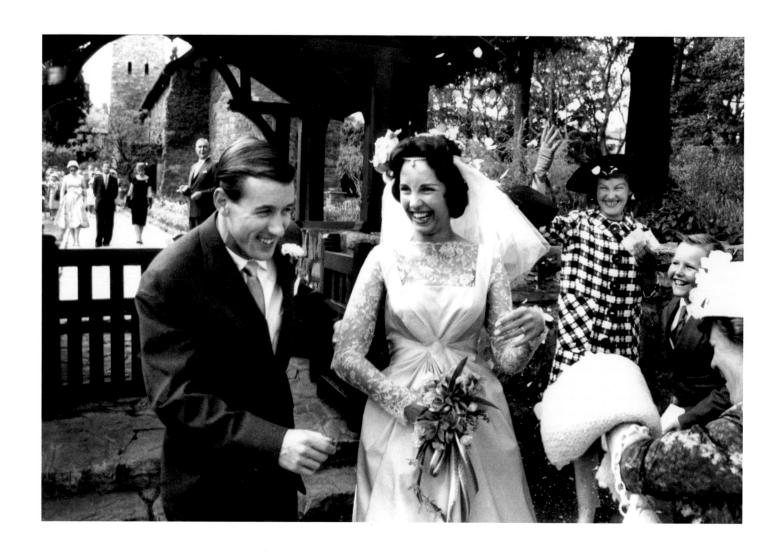

Journalist Adrian Porter married in style in the Northern Suburbs of Johannesburg.

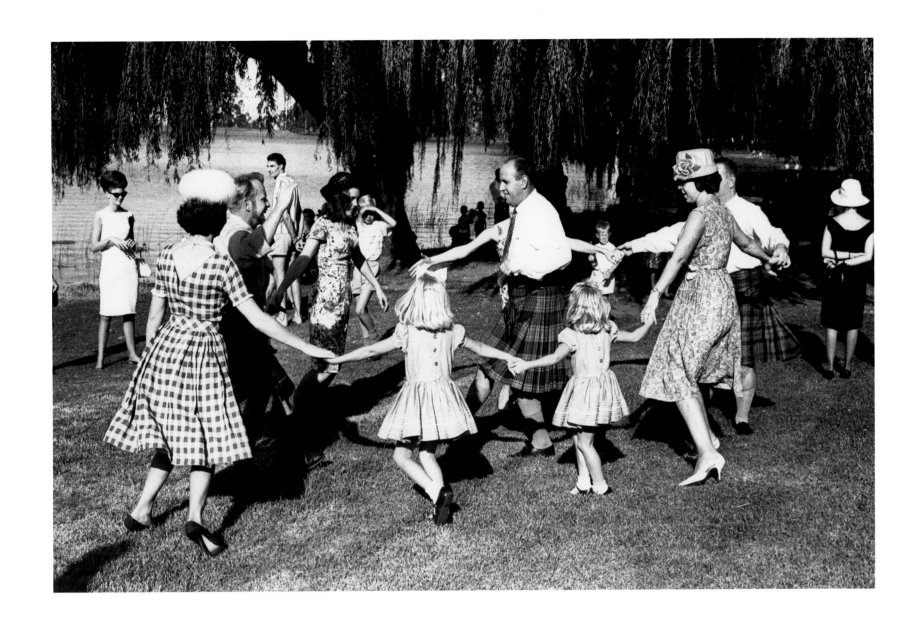

Festive picnics, merriment and jollity at Zoo Lake in Johannesburg.

The "Midnight Kids" of Western Township. They were terrific. They had an enterprising leader, a schoolteacher, who endeavoured to train them. Audiences went crazy with excitement, stomping their feet, shouting and whistling at those ten-year-olds giving it all they'd got. Such promise, such talent.

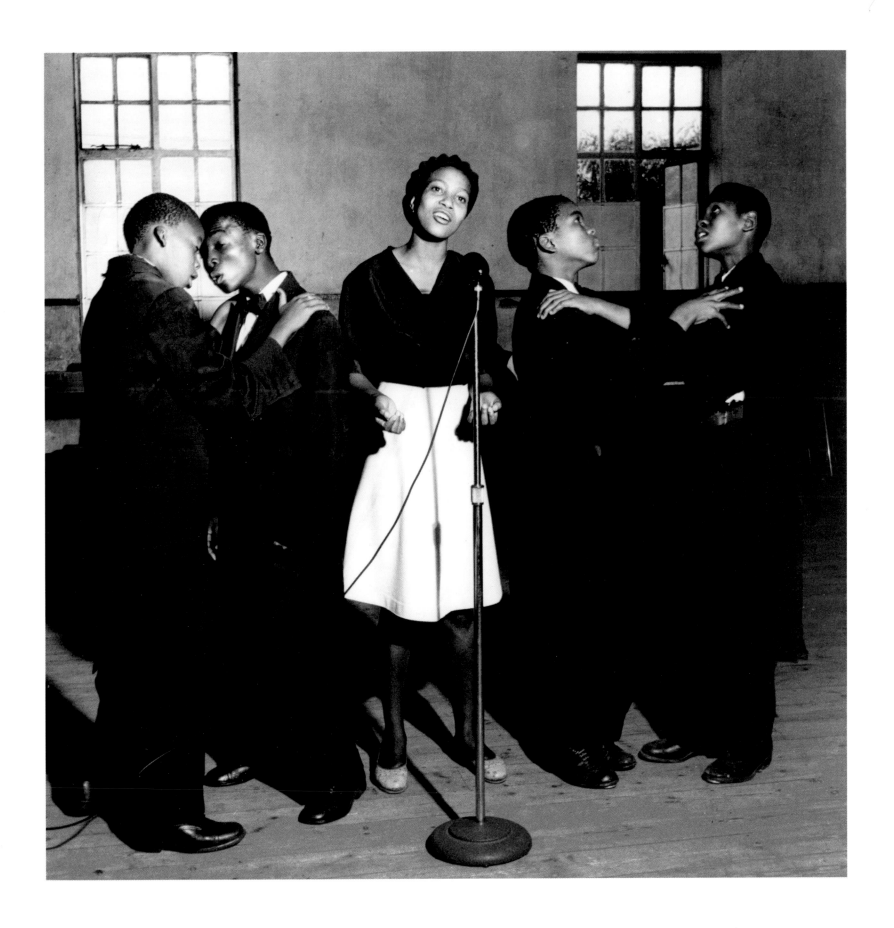

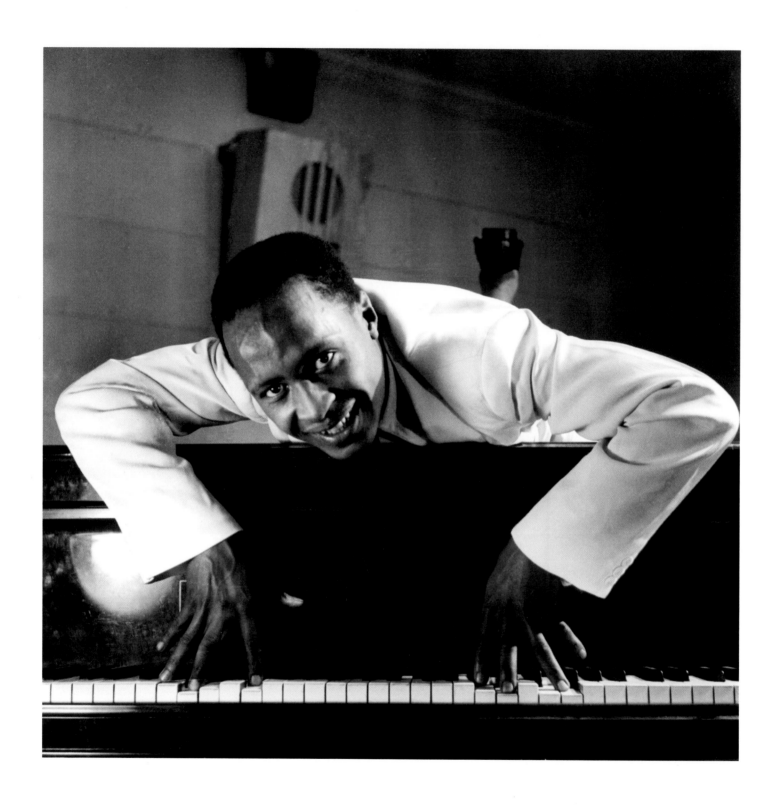

Boycie Gwele, showman, played the piano in a number of big bands (above).
Todd Matshikiza called these five harmony singers "The Sizzling Sizzeleties" (right).

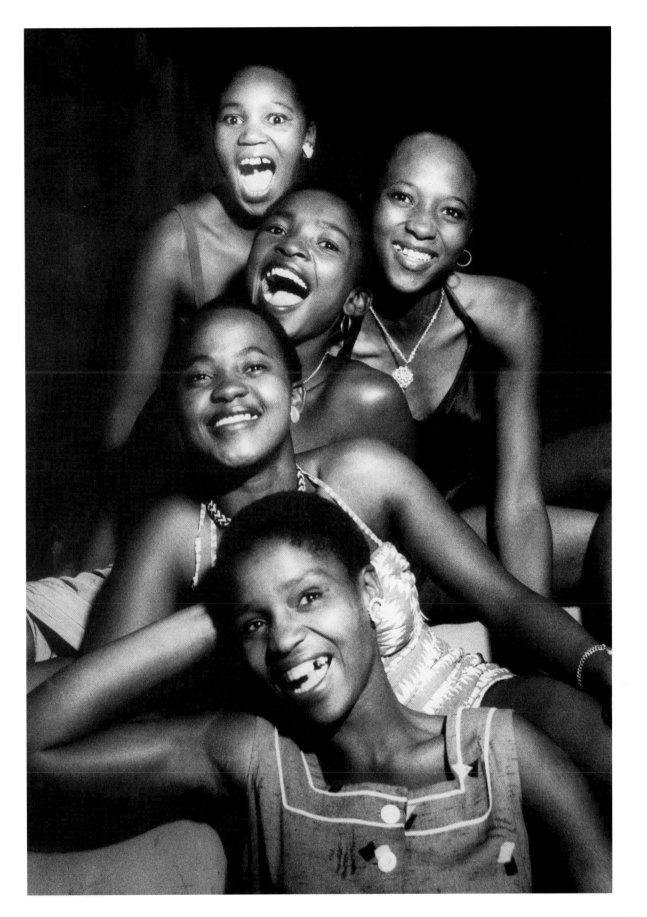

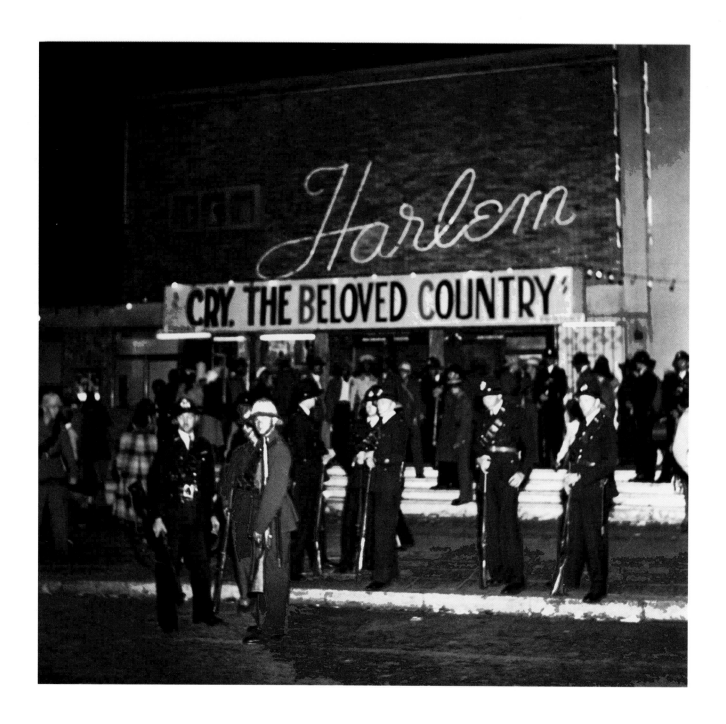

Alan Paton's book "Cry, the Beloved Country" was made into a film in 1950. The film was an attack on the extreme injustices caused by racism in South Africa. It premiered in a number of alternative cinemas round the country, including the Harlem Cinema in Fordsburg, Johannesburg, where the police were out in full force (above). The Annual Durban July Horse Race was the highlight of the social calendar (right).

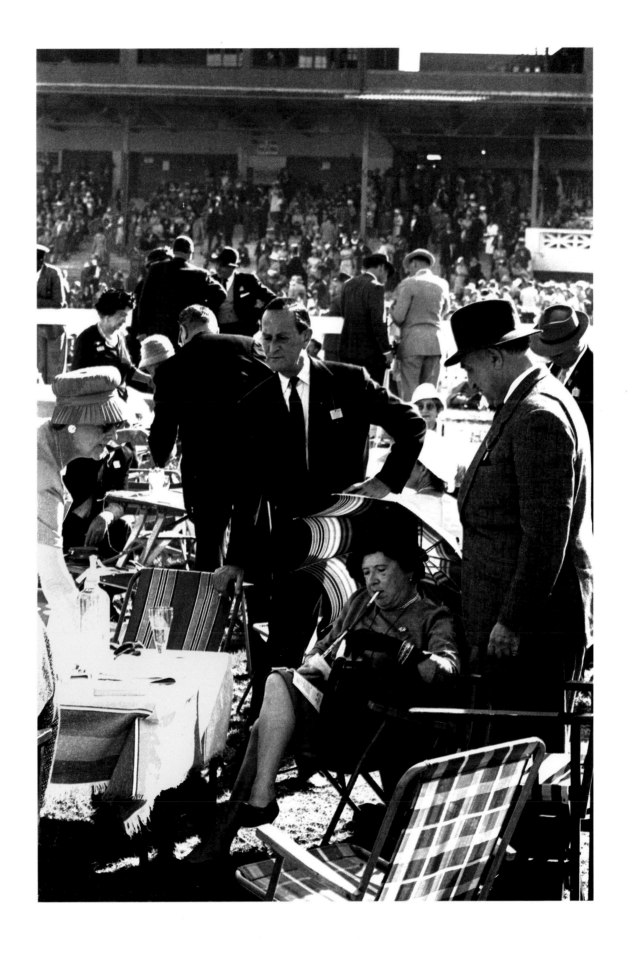

Ballroom acrobatics. Ballroom dancing was, and still is, one of the most popular pastimes in South Africa.

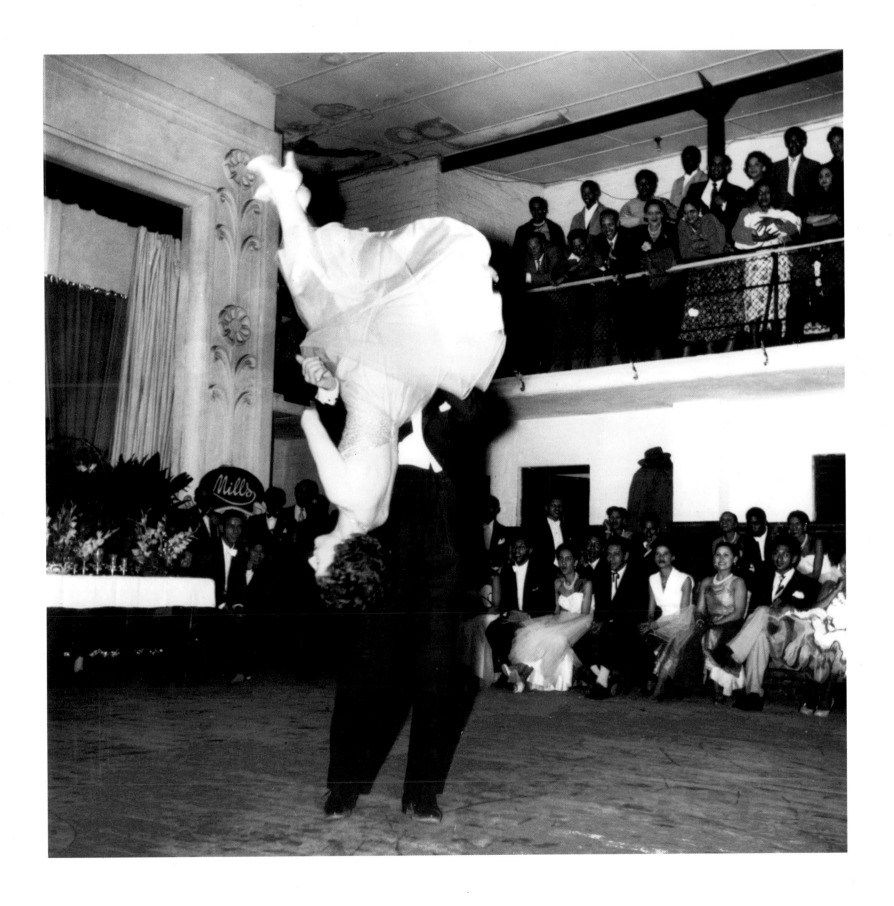

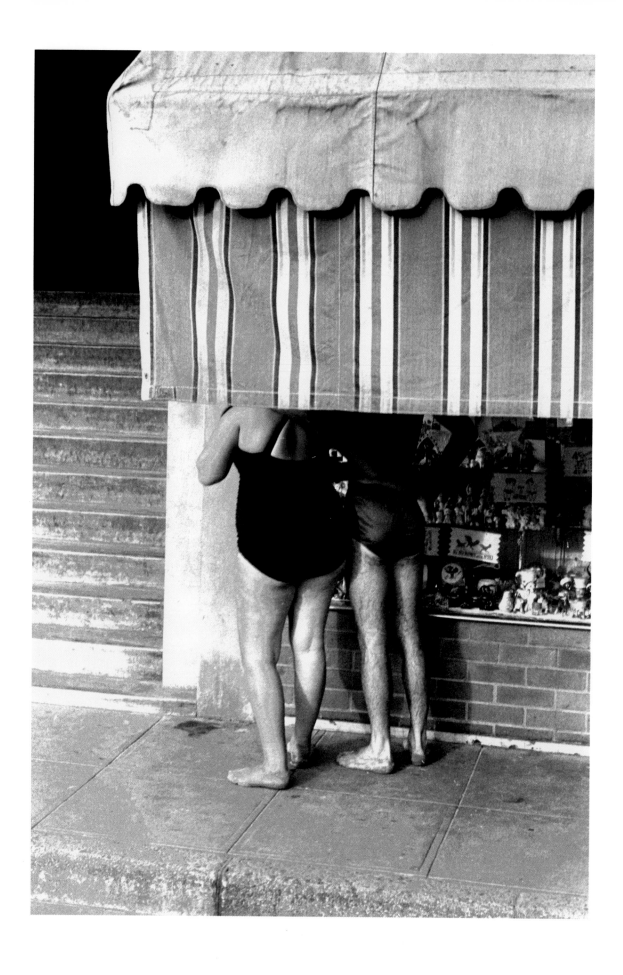

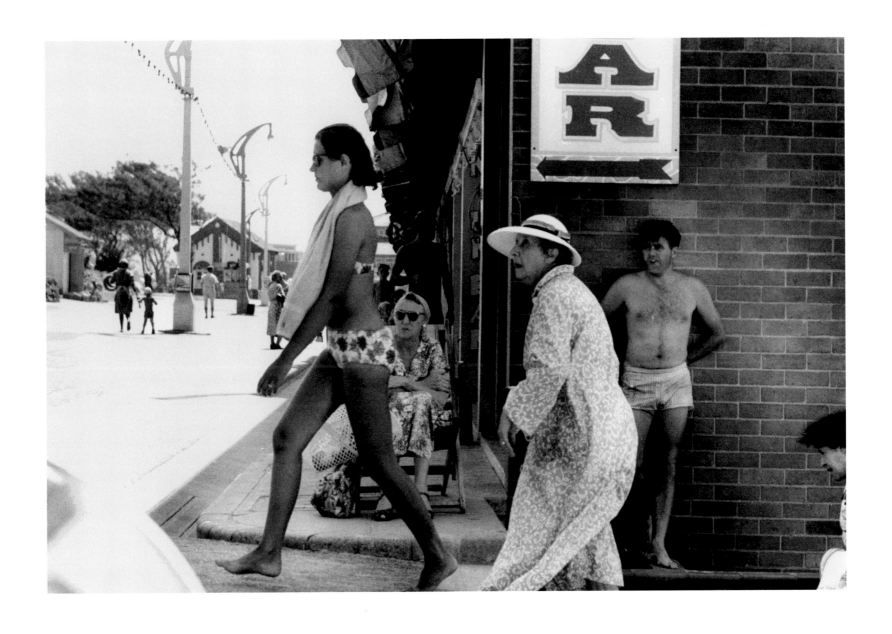

In Durban there were separate beaches for Whites, Indians and Zulus, all clearly racially demarcated.
The Whites were sunbathing for a darker skin and the darker-skinned people avoided the sun for a fairer skin.

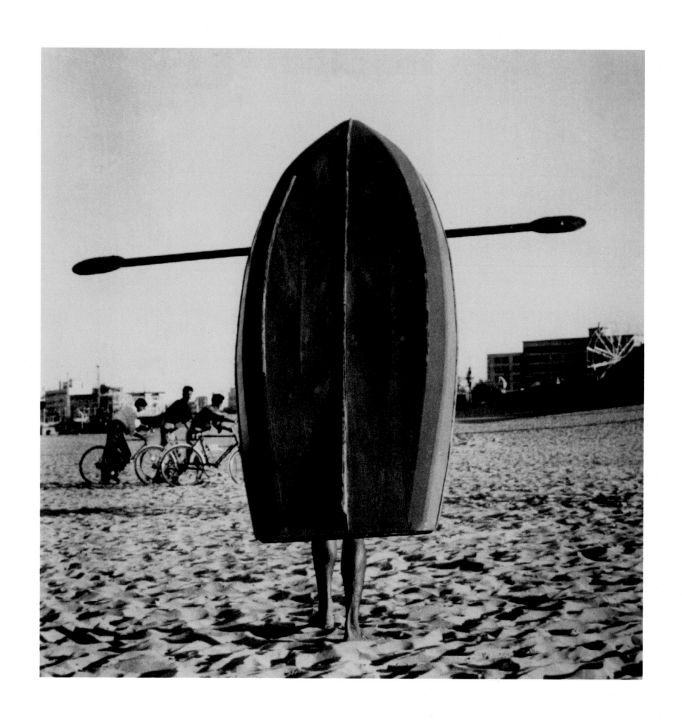

Surf Board Fifties style on a Durban beach (above).
Ditch Workers in Jo'burg rhythmically pounding and singing (right).

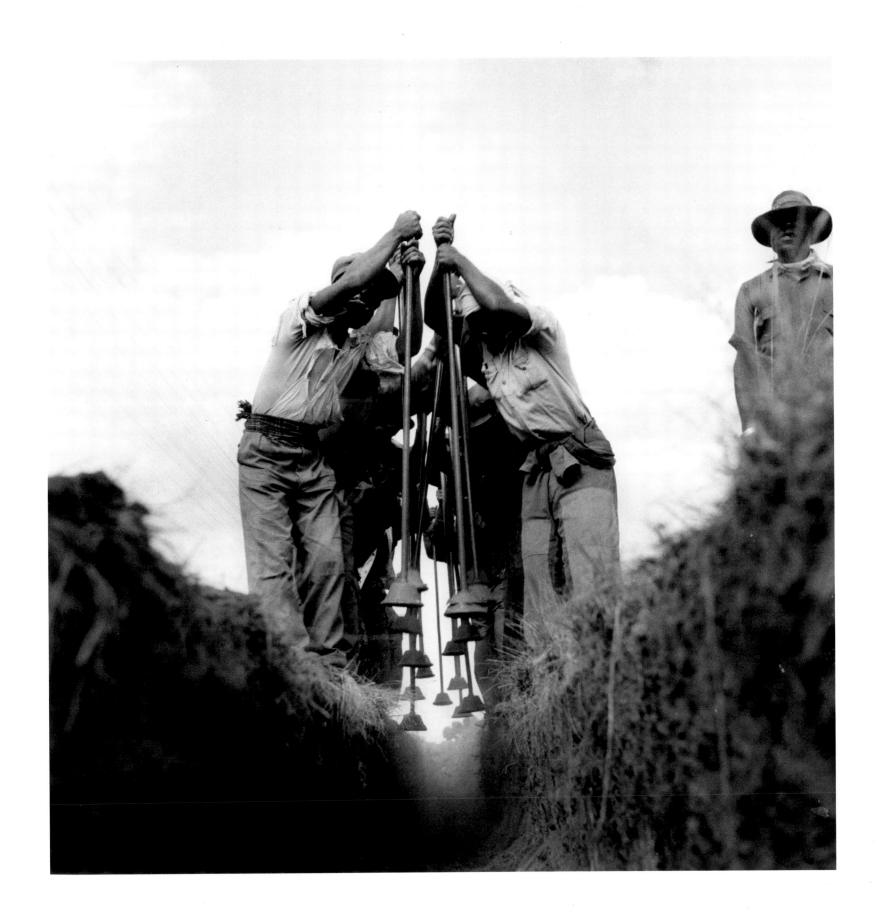

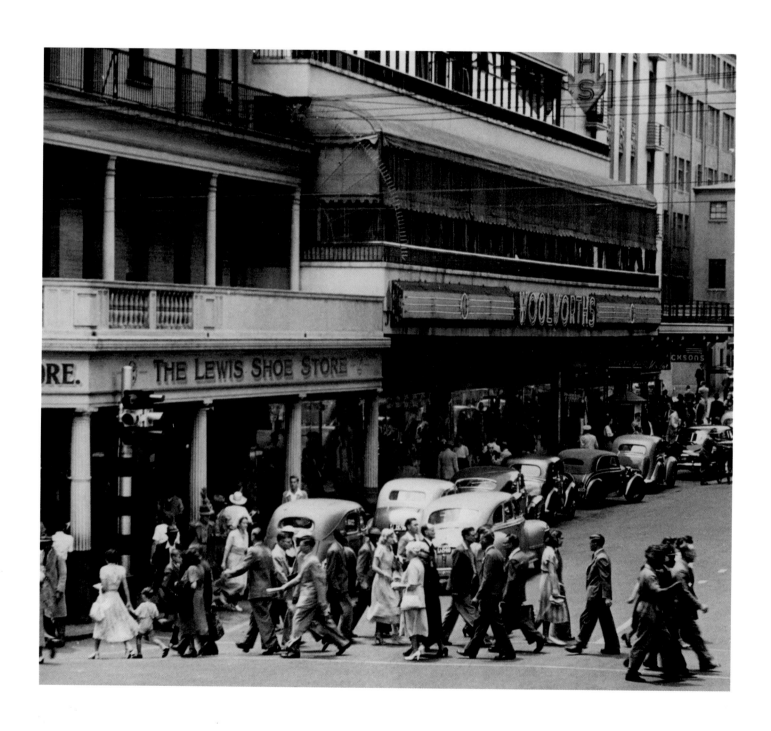

White City of Johannesburg in 1951 (above) and the makeshift houses in Orlando squatter camp, outside Johannesburg (right).

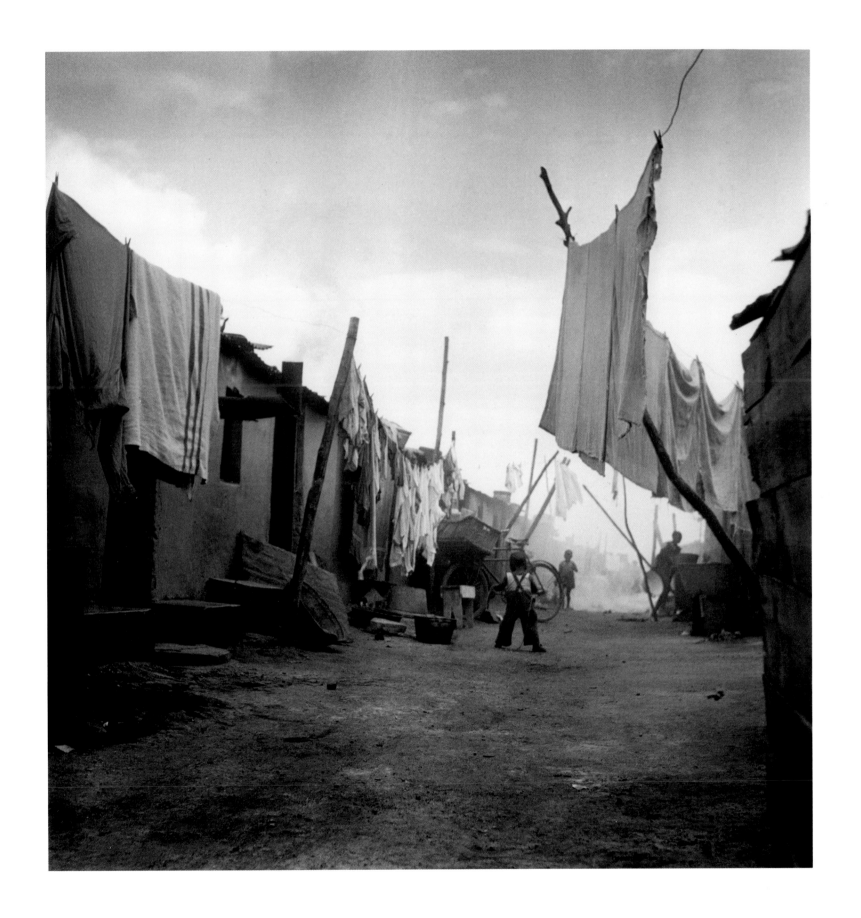

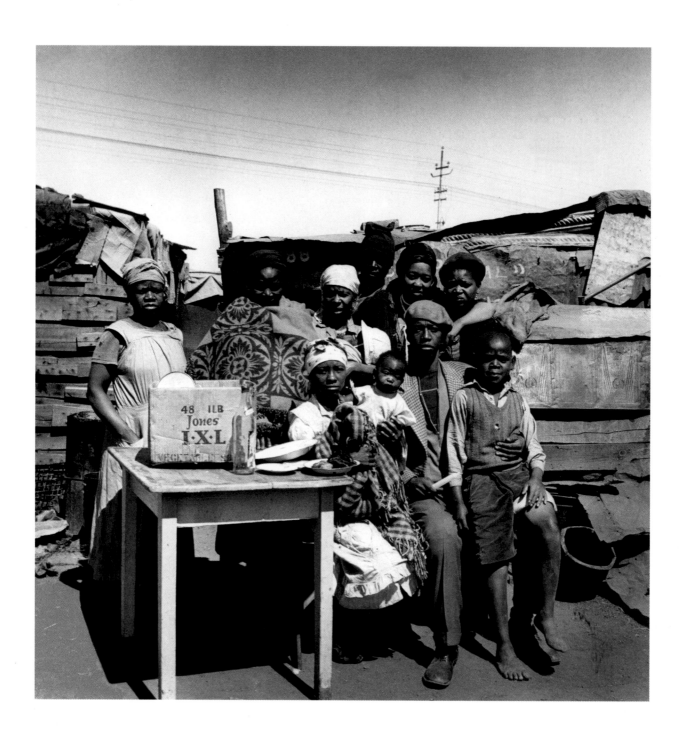

Squatters on the outskirts of Johannesburg ... they came from all over the country to make their fortune in The Golden City (above).
Throughout the City there were sounds of pennywhistles and guitars, and the pennies were flying onto the pavement (right).

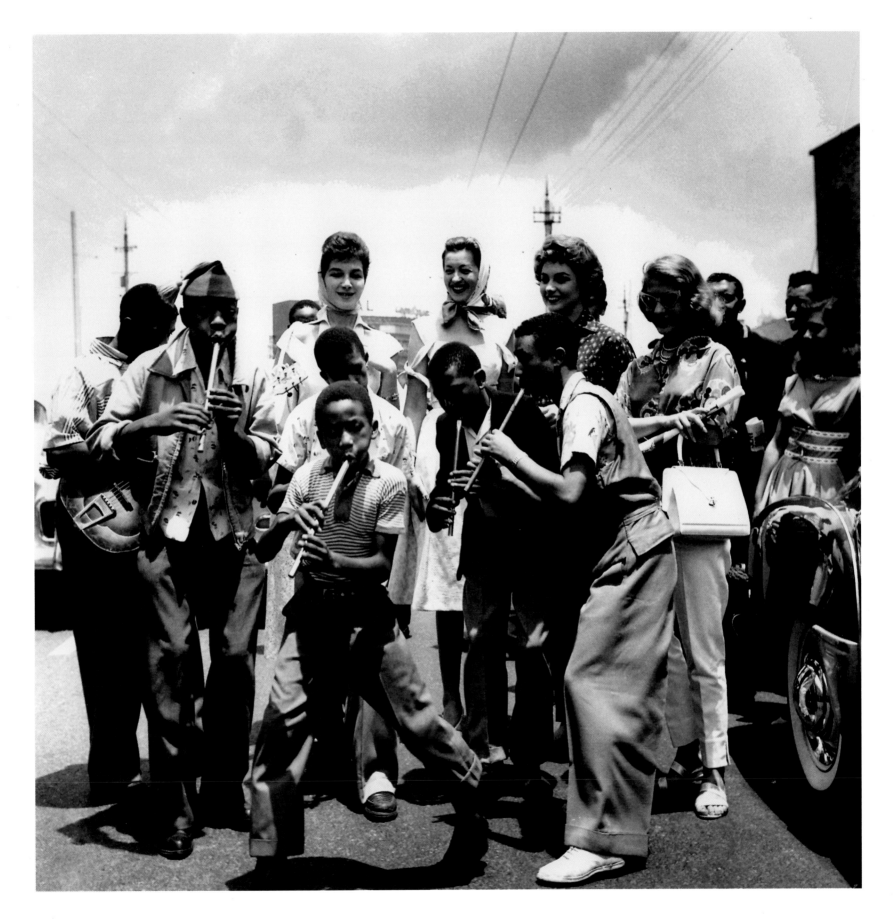

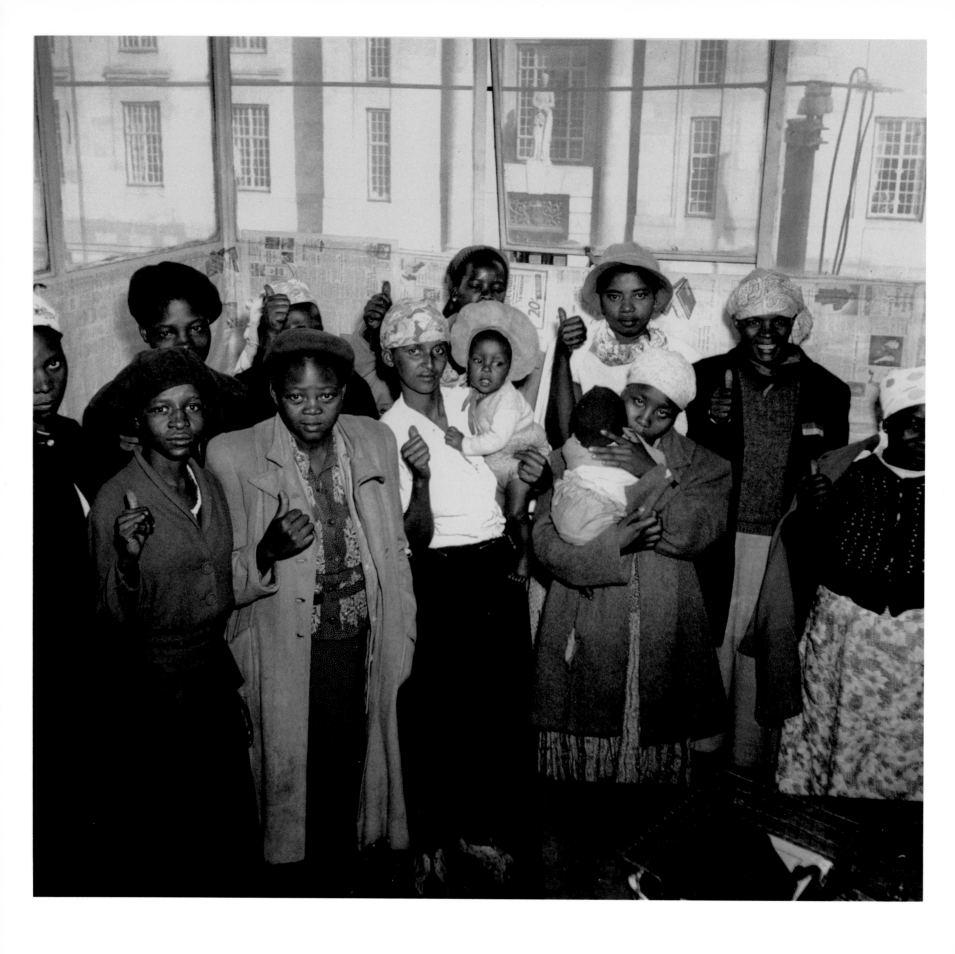

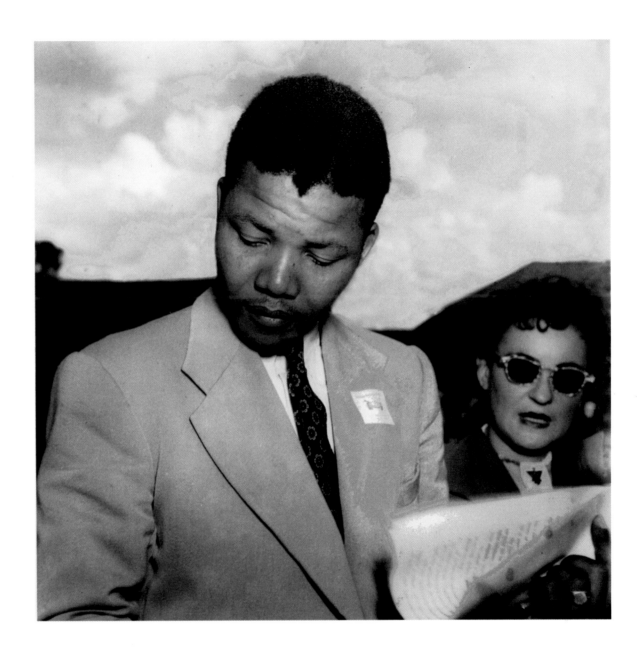

Nelson Mandela and Ruth First at the ANC Conference in December 1951 in Bloemfontein where the Defiance Campaign was conceived and planned (above). Women of the ANC in Johannesburg participating in the Defiance Campaign (left).

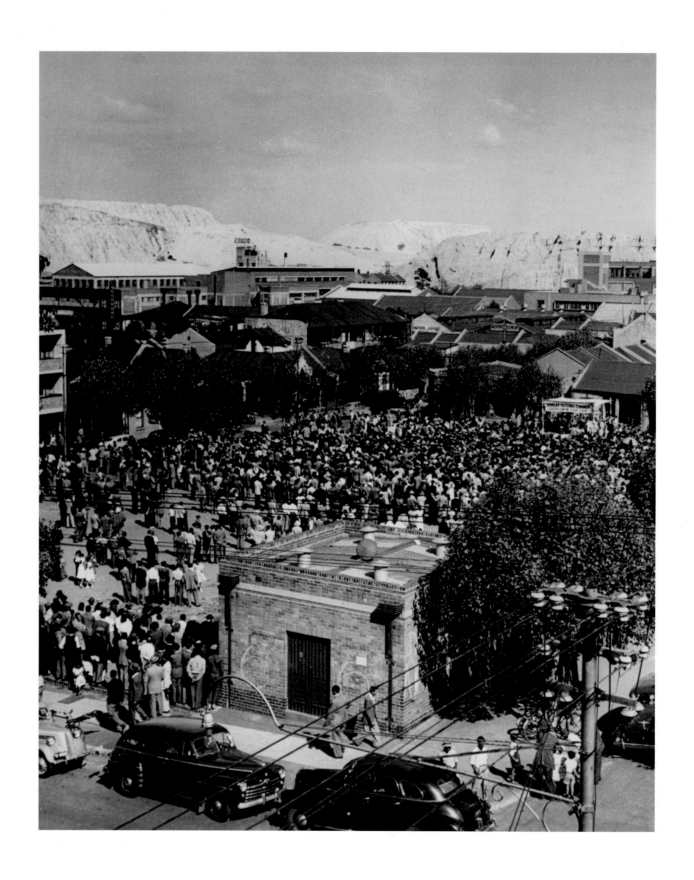

"Freedom Square", Fordsburg, at a Defiance Campaign meeting, 6th April 1952.

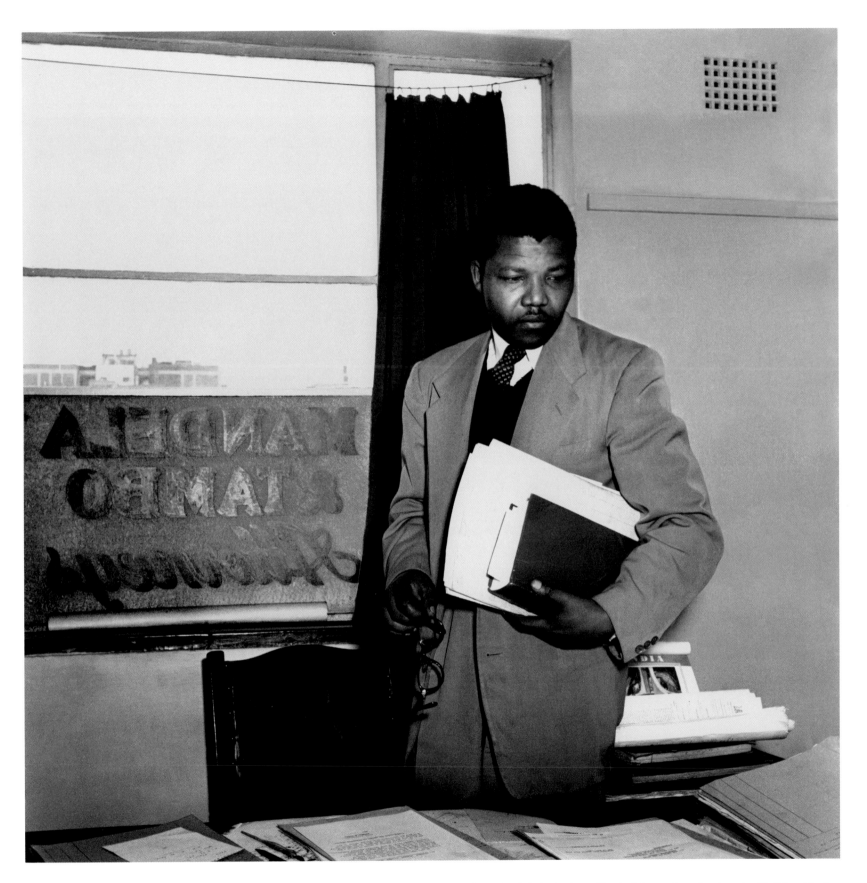

Nelson Mandela in the law office in Johannesburg he shared with Oliver Tambo.

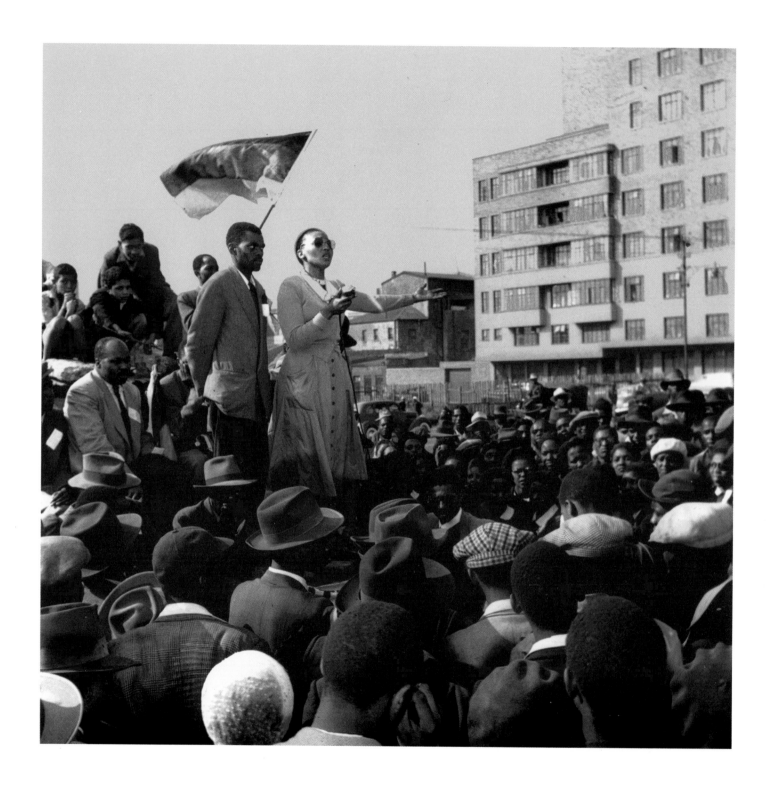

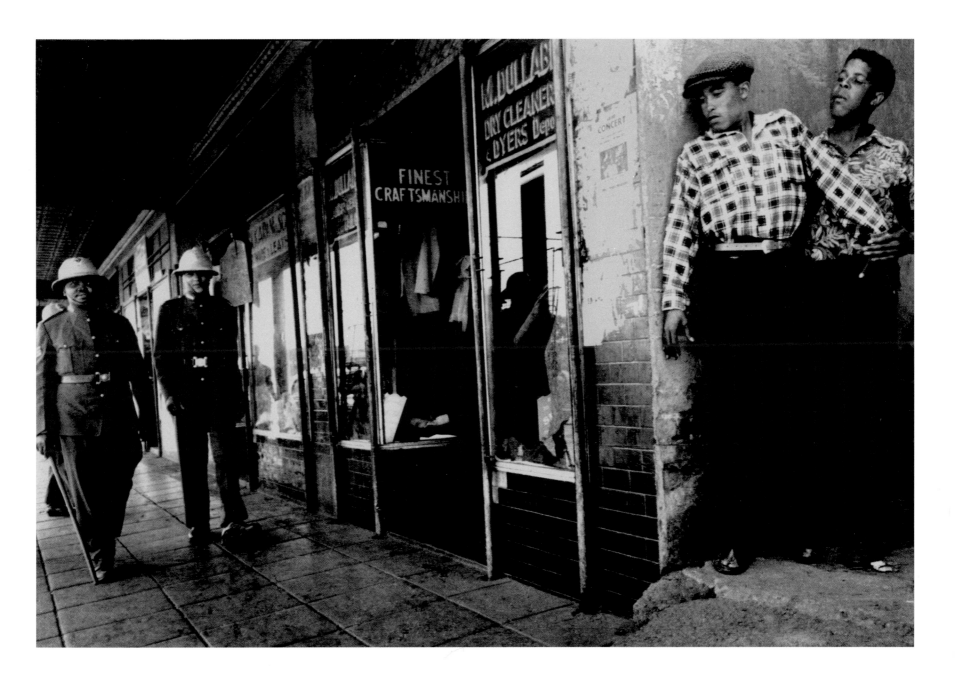

Blacks had to carry passes. If they were caught in the City without a pass they would be thrown in jail (above). Violet Hashe, fiery trade union leader, calls out to the people at "Freedom Square" in Fordsburg to defy the unjust laws introduced by the Apartheid government(left).

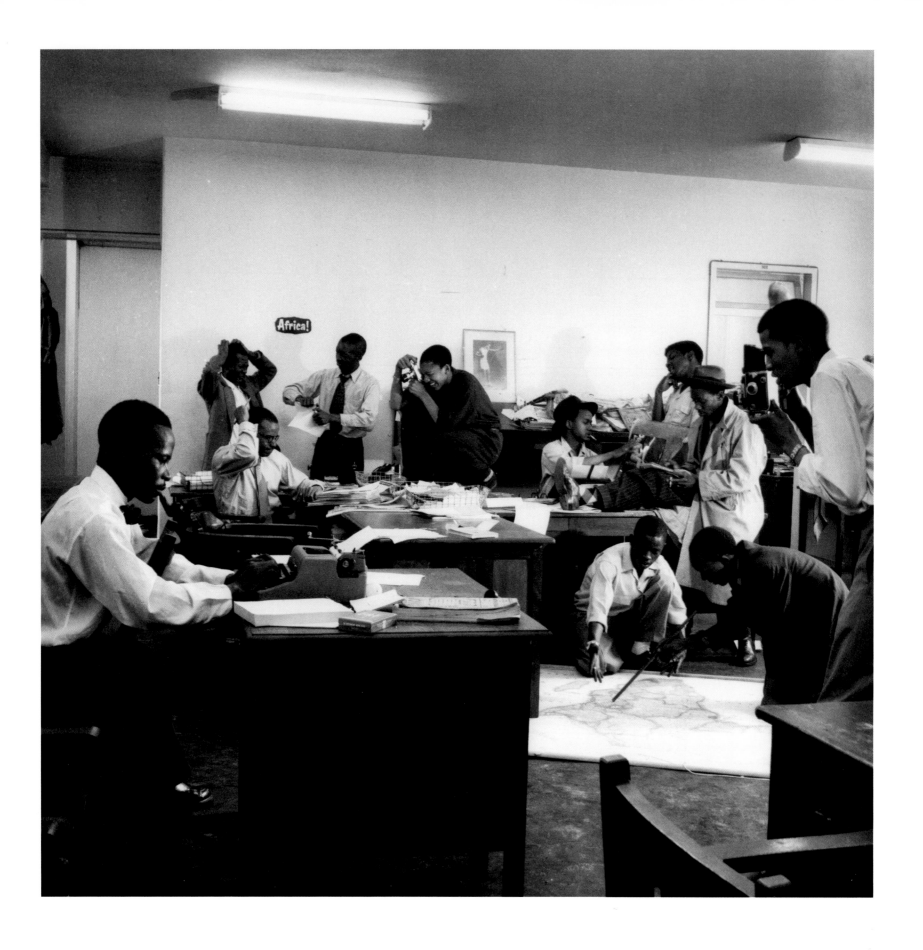

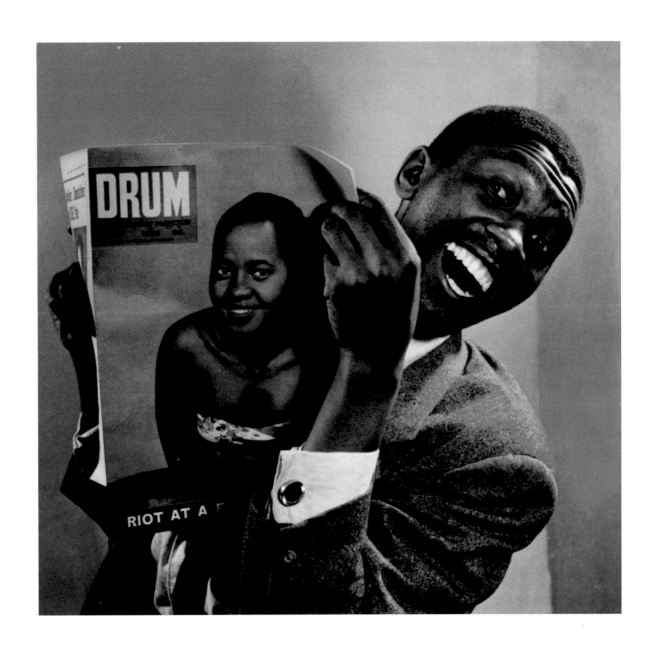

Sol Rachilo, actor and entrepreneur, posing for a promotional pamphlet for "Drum" which was the first magazine in South Africa that featured black cover girls (above). The Drum office in Johannesburg (left) with Henry Nxumalo, Ezekiel Mpahlele, Casey Motsitsi, Can Themba, Arthur Maimane (wearing hat, drooping cigarette), Victor Xashimba, Dan Chocho and Bob Gosani (right with camera).

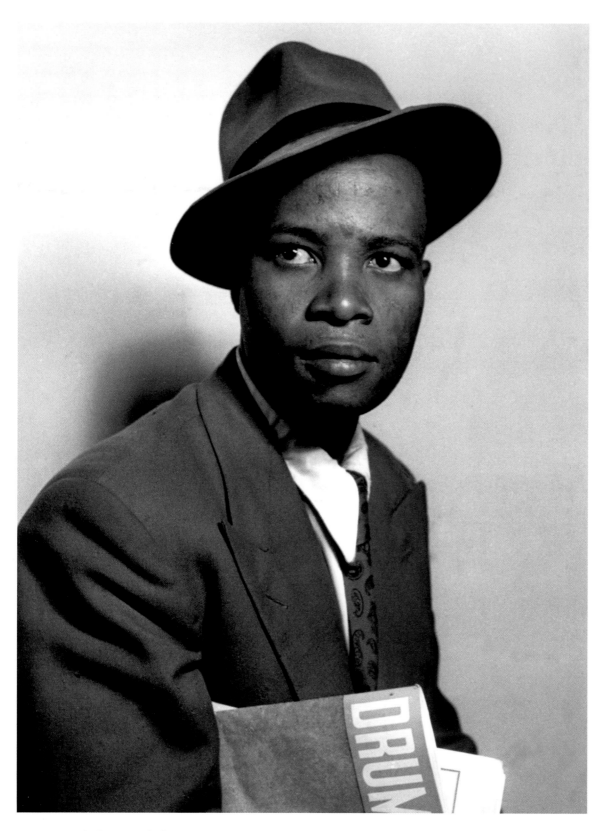

Henry Nxumalo (Mr. Drum), the most courageous investigative journalist. Henry fought to expose injustice, cruelty and narrow-mindedness and was murdered while working on a story about a white doctor who performed illegal abortions that resulted in many deaths.

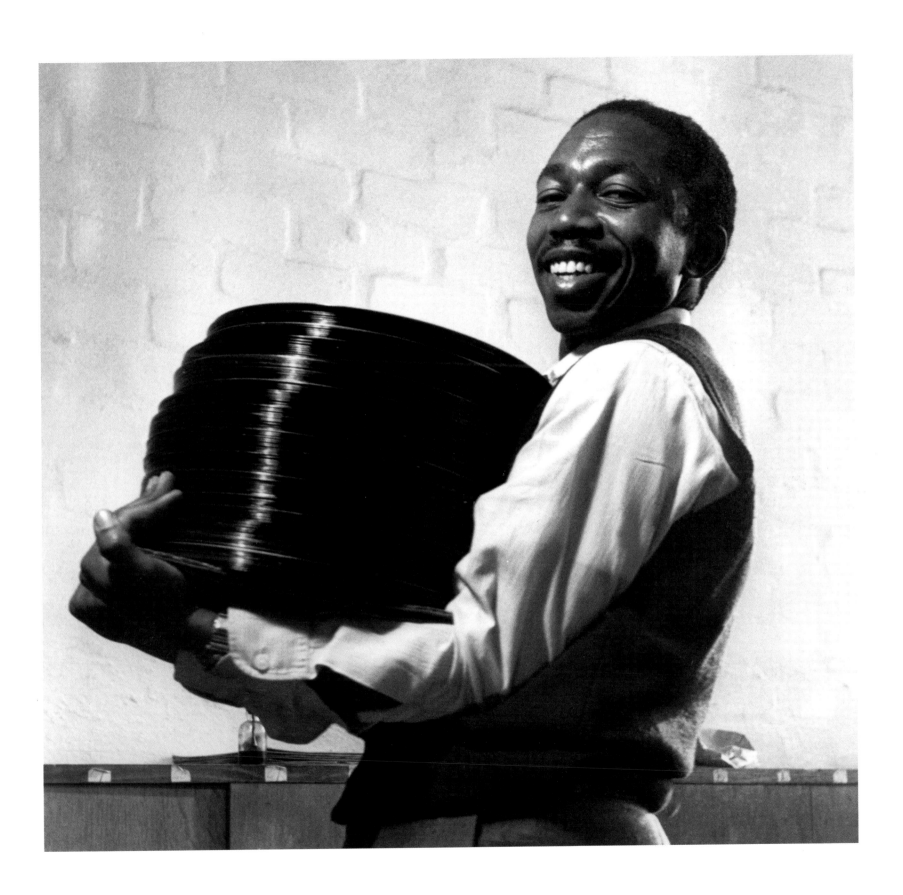

Todd Matshikisa, composer, music critic and Drum writer, played the English language on the typewriter as he played his music on the piano ...

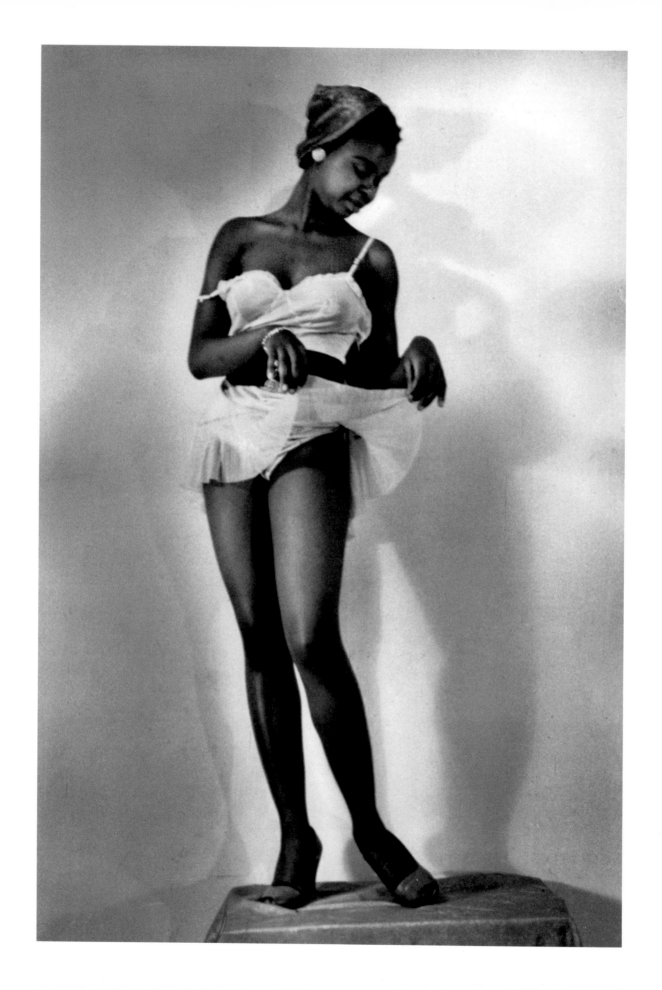

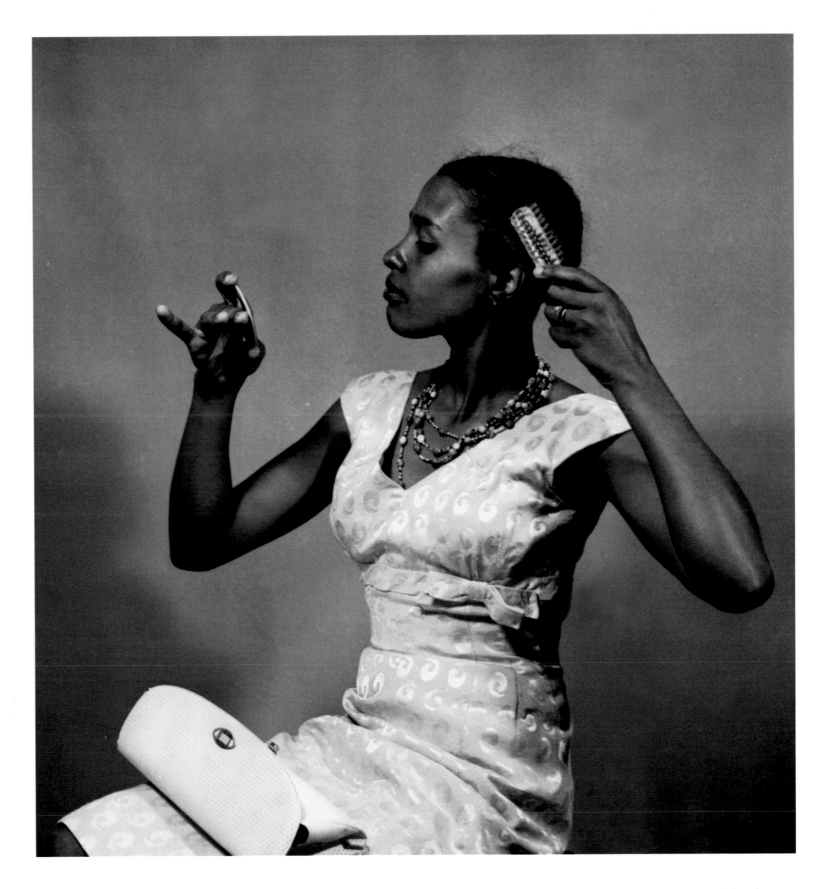

Priscilla Mtimkulu described by Can Themba as "sweet and twenty … this lovely has fluttered in from Orlando East like a butterfly … you should see her eyes, soft, dreamy, sadly sweet … and her hair, wavy, wisps of black silkiness" (above). Model and singer Ruth Molefi, described by Todd Matsshikiza as "a cute fashion conscious little dame, sizzling with appeal" (left).

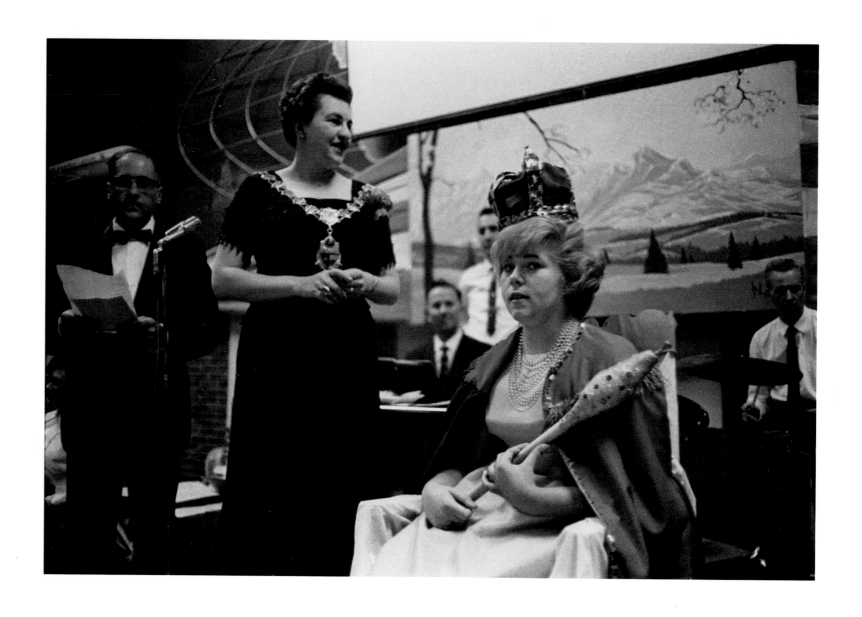

A beauty competition attended by the Mayoress of Benoni.

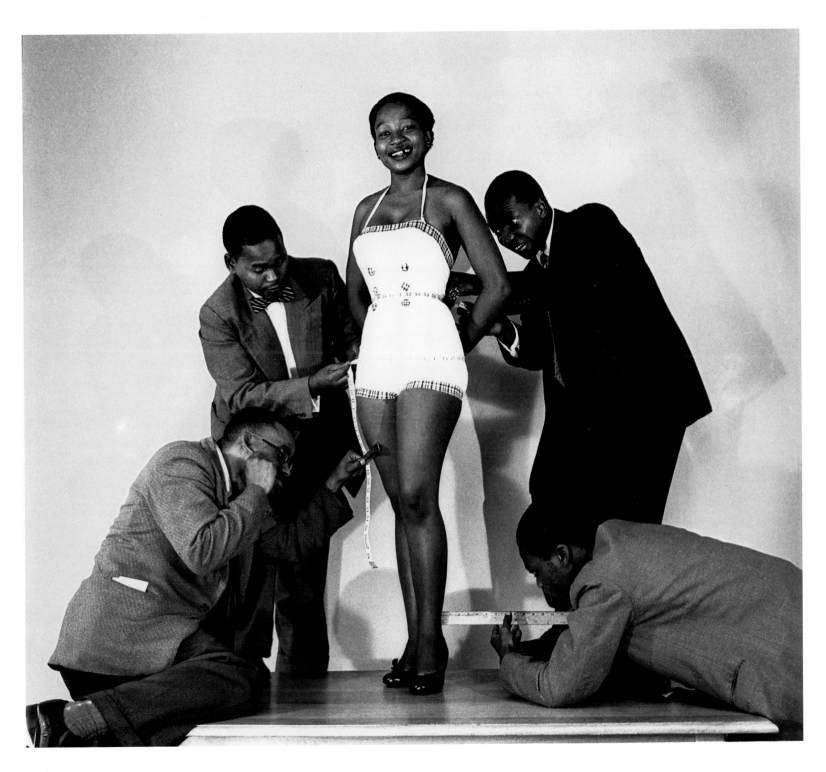

Drum cover girl being measured by Drum staff: writer Ezekiel Mphahlele (bottom left) and writer Bloke Modisane (standing top right).

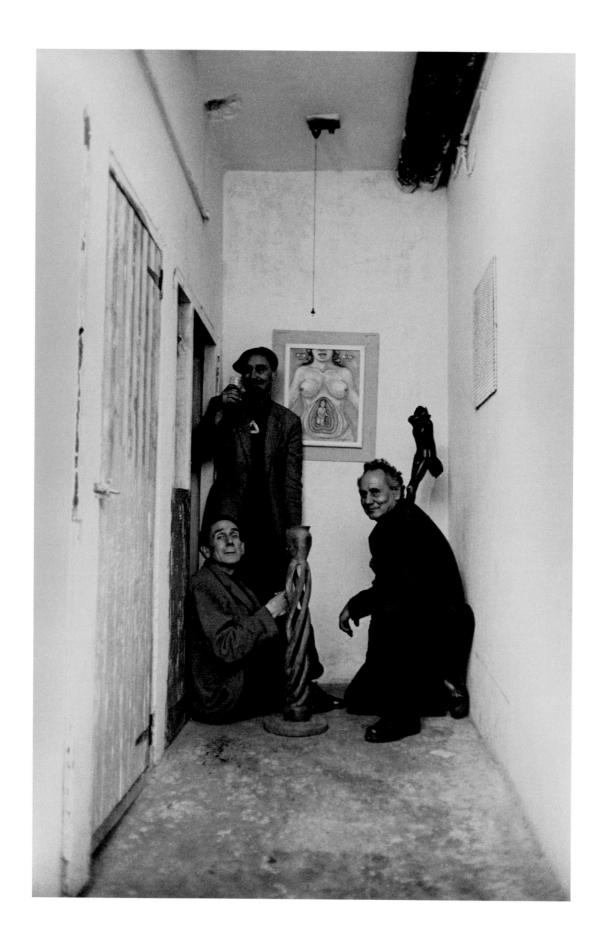

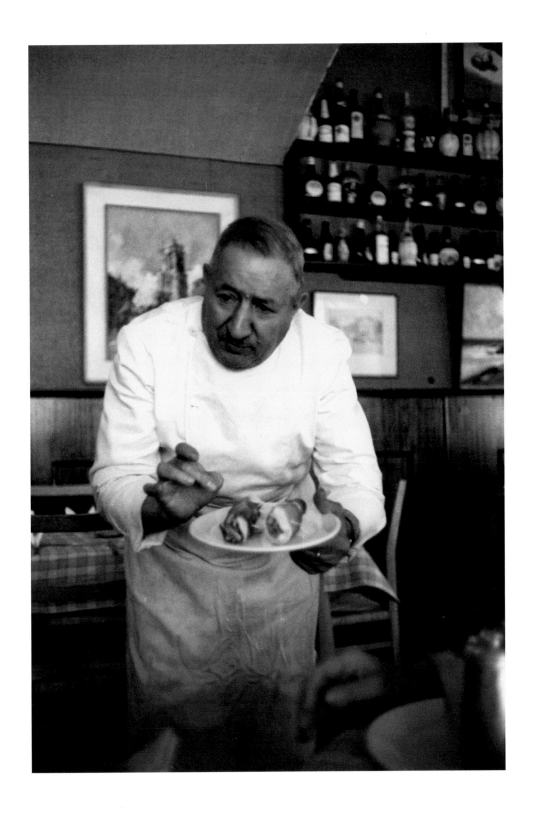

In the flatlands of Hillbrow the Bohemians of Jo'burg congregated: the artists and the hippies (left) and the continental restaurants of Hillbrow (above).

And in the old Johannesburg you found the betting shops ... horse racing was one of the oldest established sports in the city.

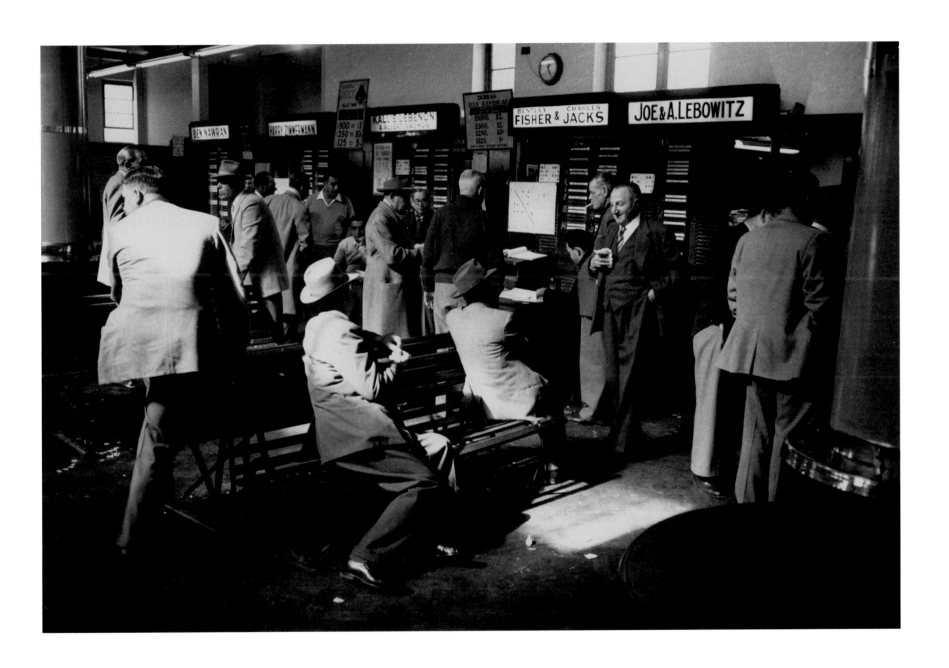

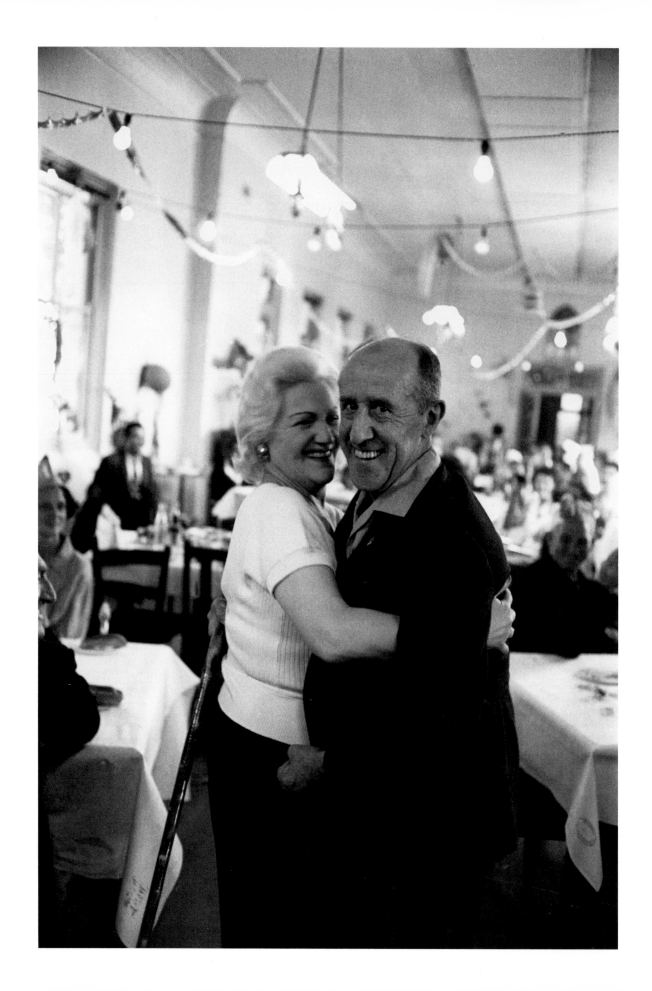

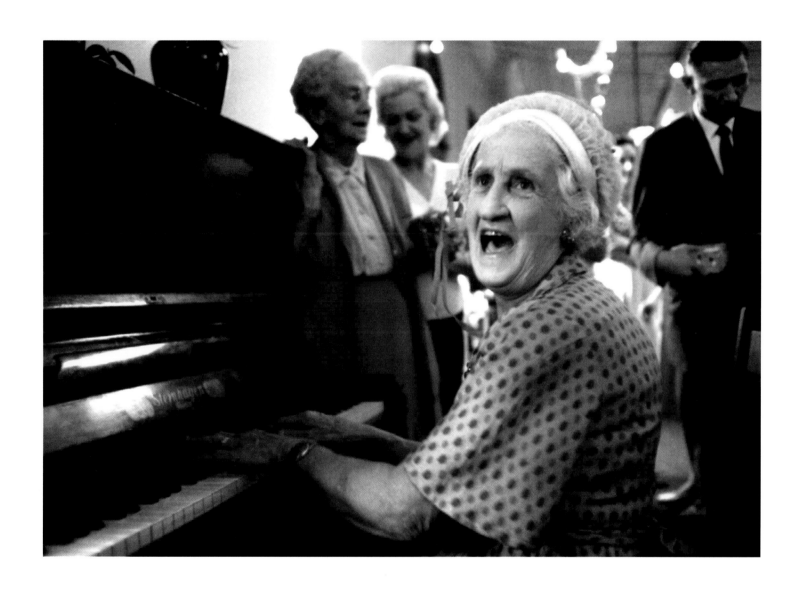

A Christmas party at an old aged home.

Stylish wedding celebrations in Jo'burg.

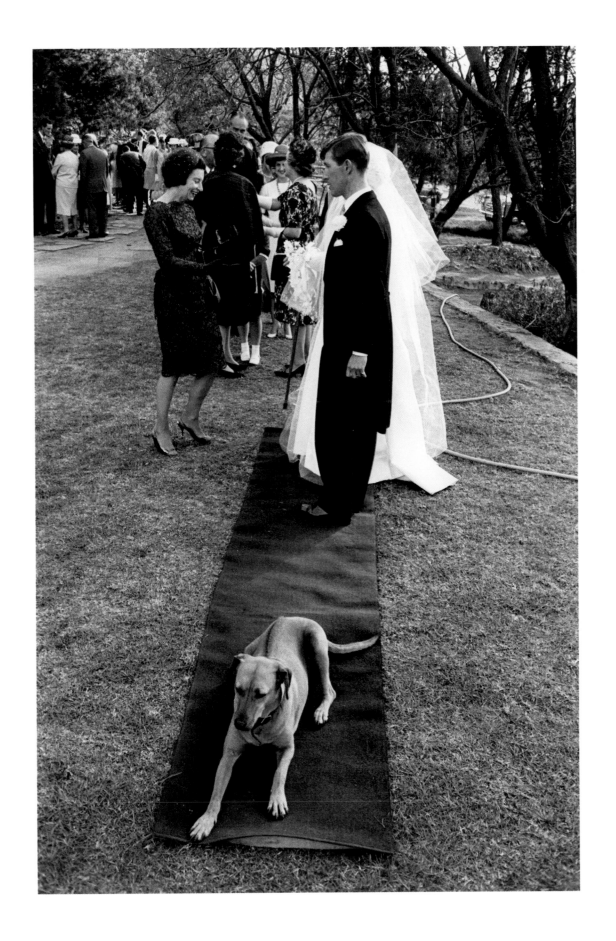

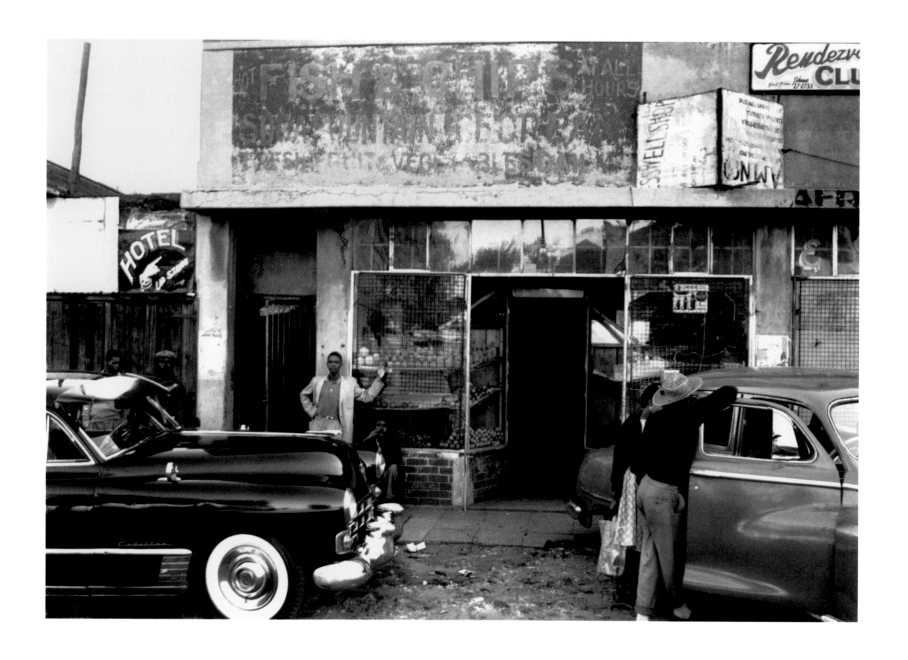

Sophiatown, the City within a City, the "Gay Paris" of Johannesburg, the centre for cosmopolitan cultural, social and political happenings.

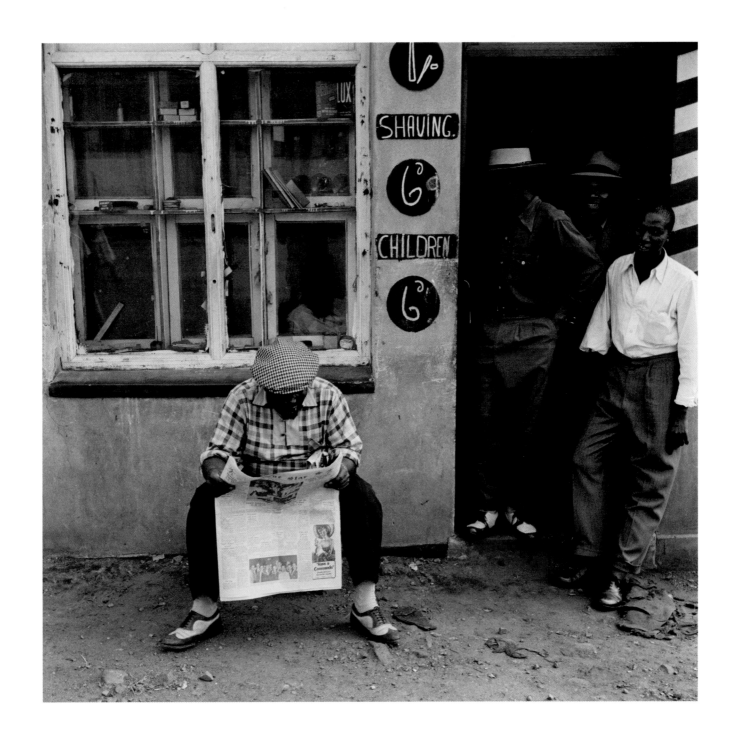

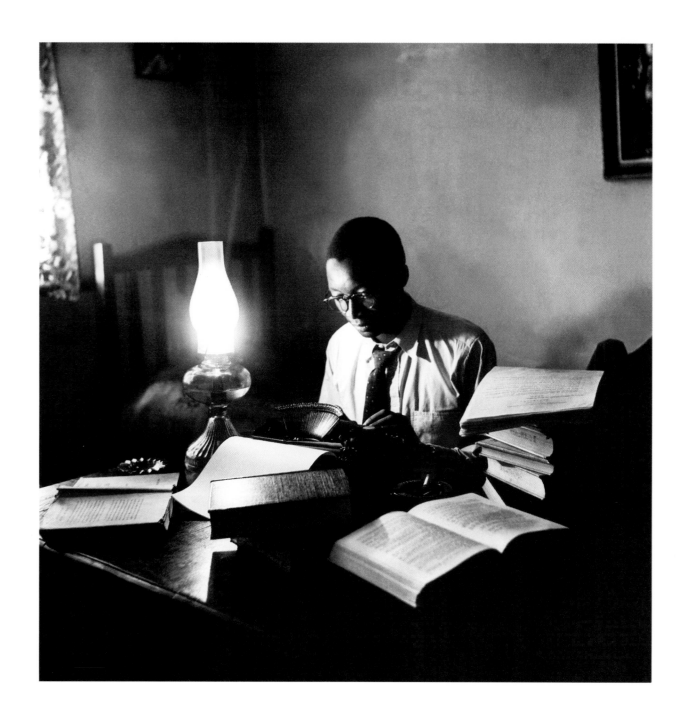

Writers, musicians, politicians and journalists lived side by side with the gangsters, shebeen queens along with the Sophiatown bohemians. There was the boxer, Ezekiel Dlamini, the hero of the jazz opera "King Kong", … there was the blues queen Dolly Rathebe … and writers like Bloke Modisane, … and of course the writer/philosopher Can Themba (above), among others.

In Sophiatown, the boxing gyms were crowded with enthusiastic youngsters hoping to break away from poverty … and aspiring to be world champs.

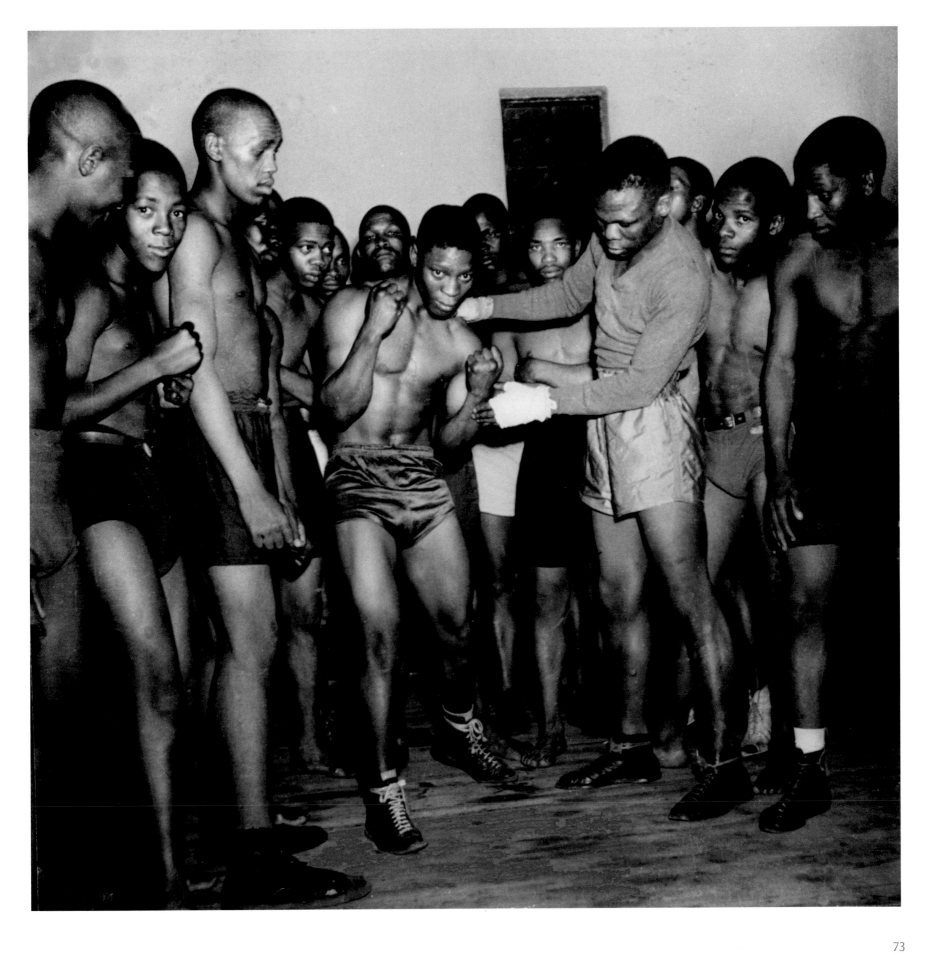

Father Trevor Huddleston, the fighting priest, was at the forefront of protests against the removals of the people of Sophiatown. "These six years in Sophiatown were for me flooded with light, a light moreover which casts deep shadows. There, for the first time, I witnessed and began to feel in my own inmost heart the full horror of racialism."

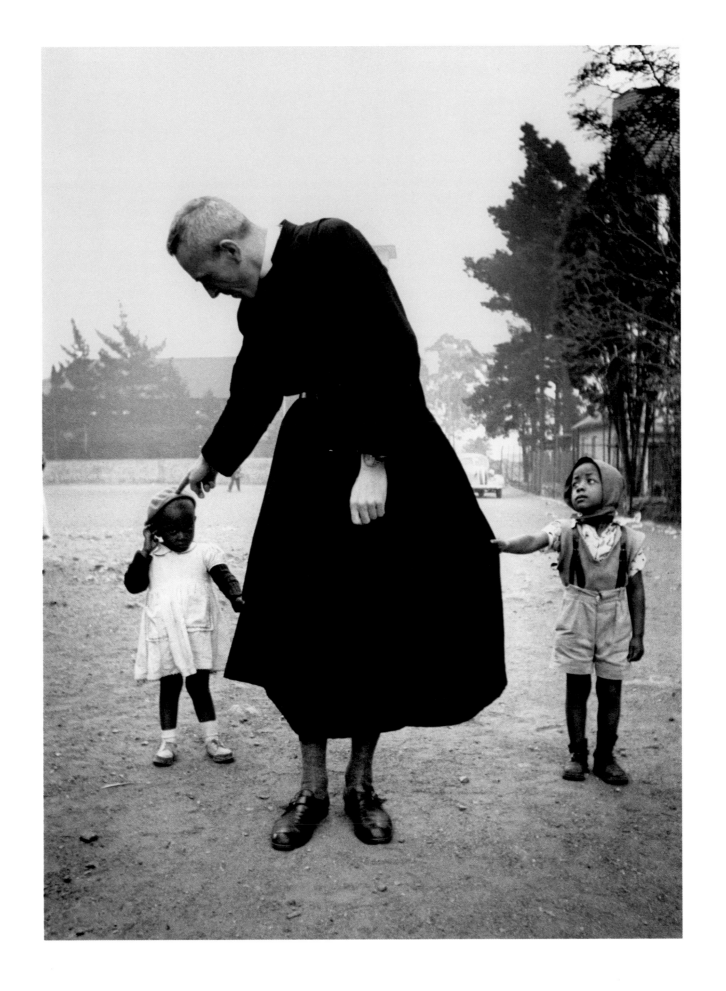

In Sophiatown the people said "We Won't Move!" ... and when the police arrived that first day, people
banged and tapped with stones and iron bars against the lamp-posts and Sophiatown echoed in defiance.

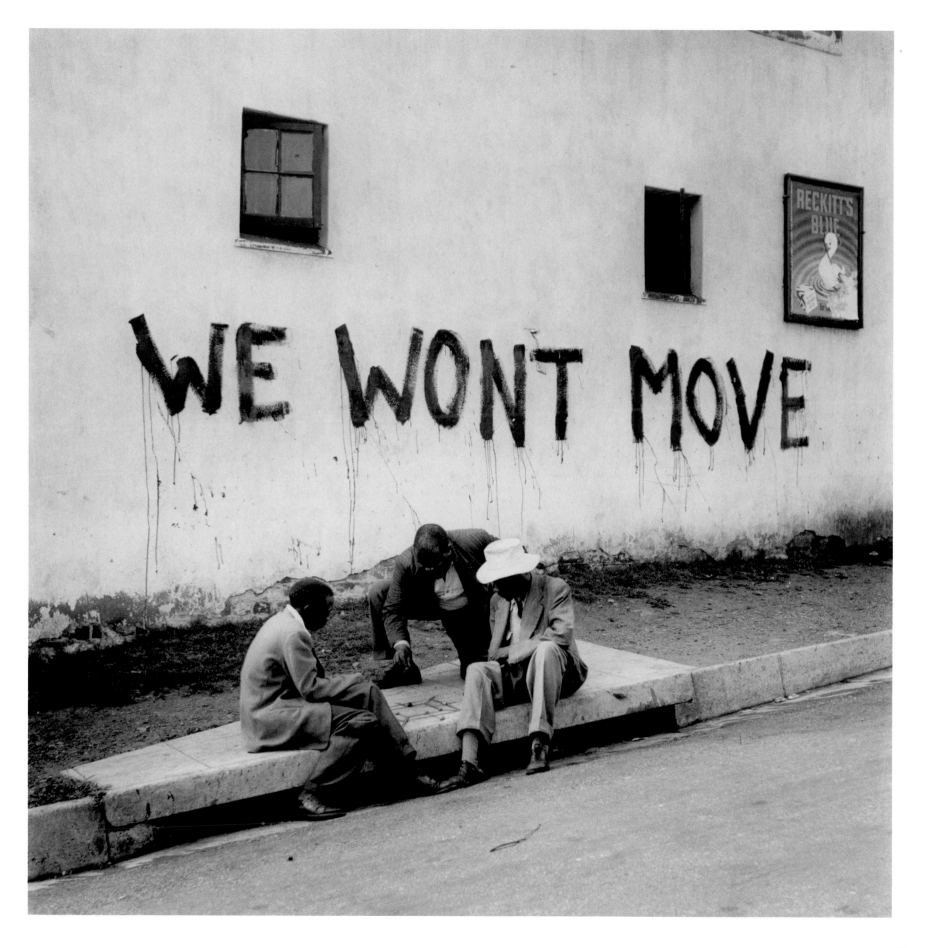

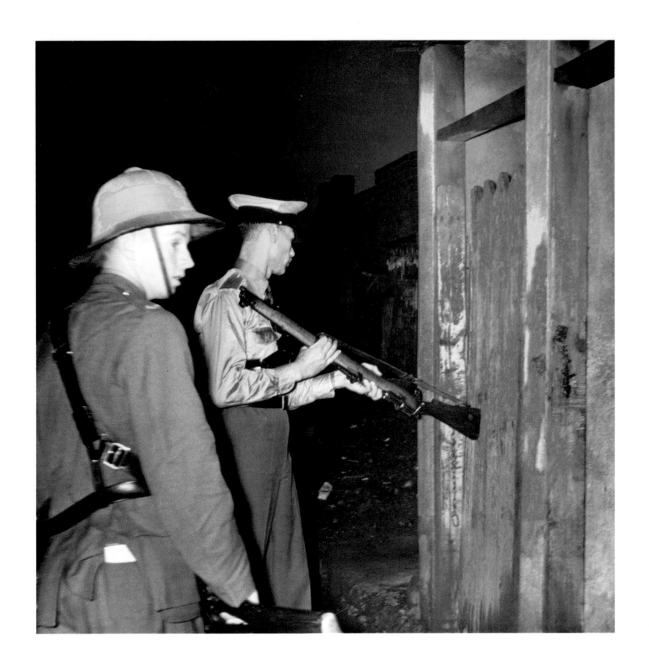

The 12th February 1955 was the day the Sophiatown removals were due to start. The ANC had called on 5000 volunteers to mobilise around the slogan of Defiance, "Asi Hami" – "We Won't Move", and a stay away was planned for the first removal day. But, on 10th February, two days ahead of schedule, eighty lorries and two thousand armed police moved into Sophiatown and began to evict the people from the homes they had occupied and owned for generations.

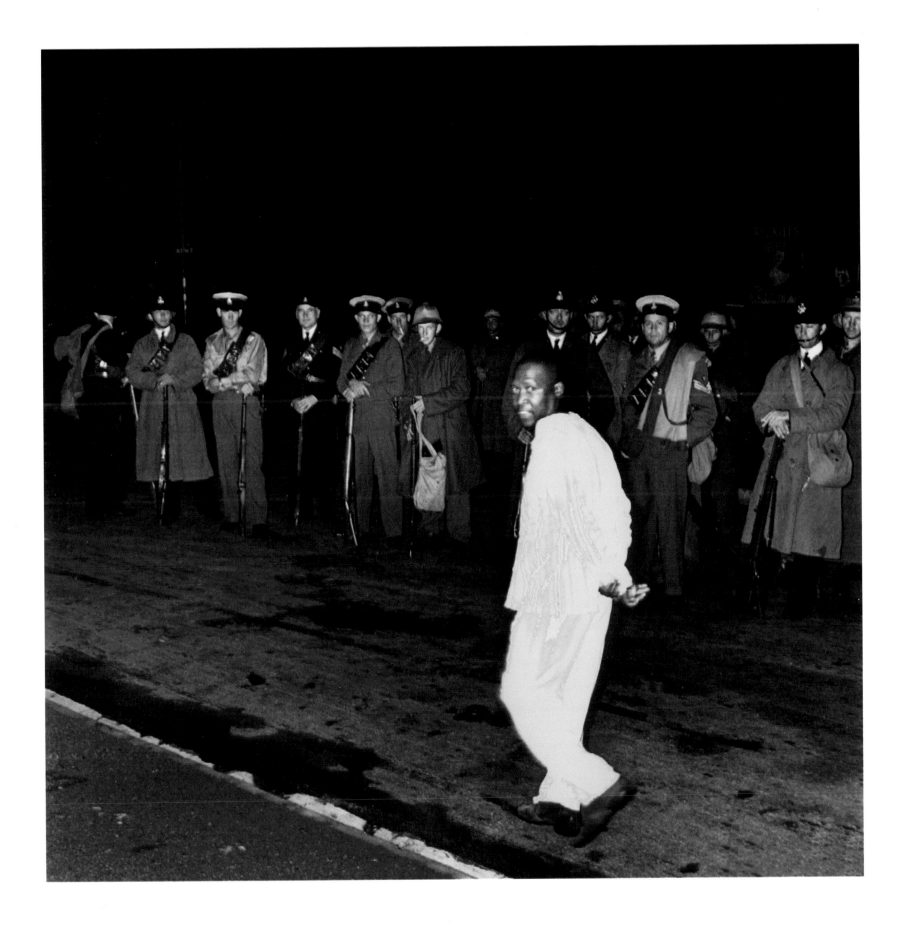

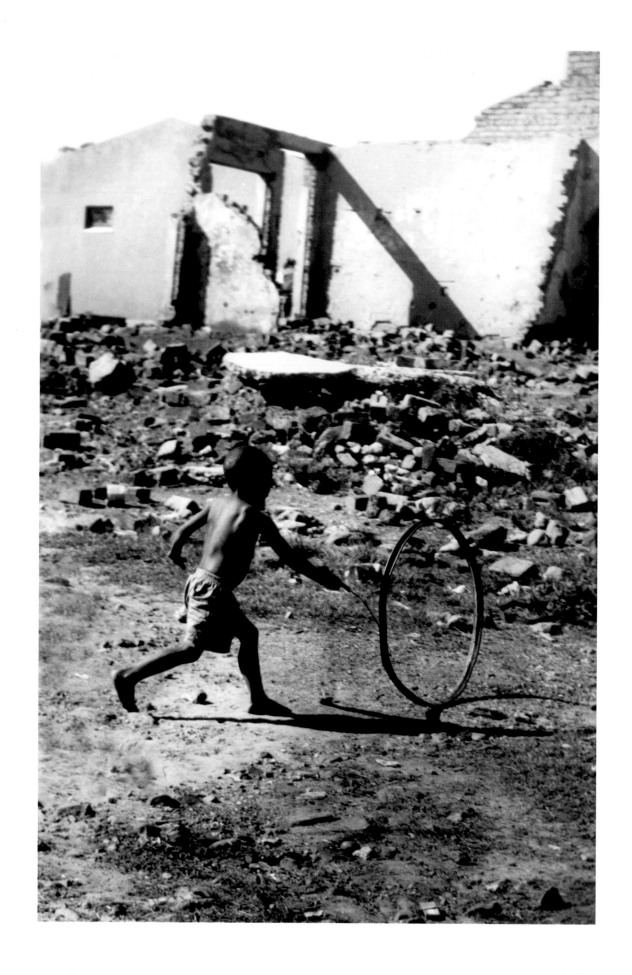

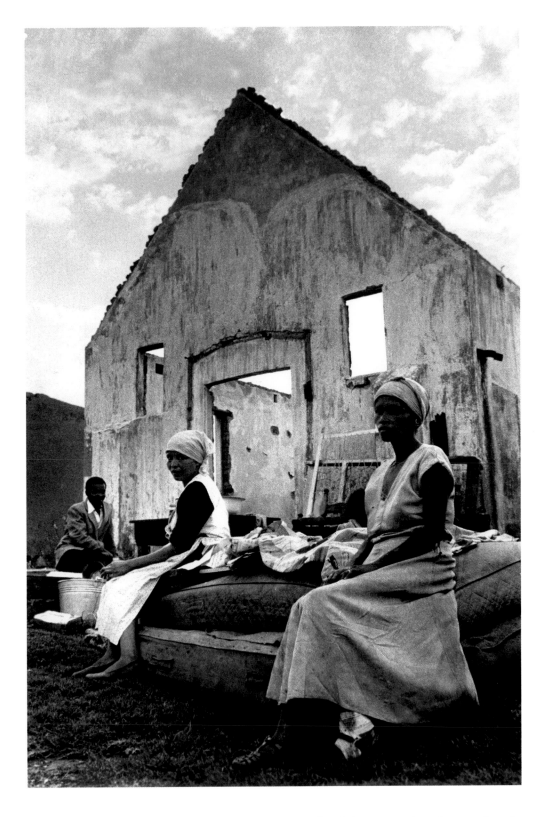

Waiting for the trucks, their homes have been demolished and they are ready to be moved to the matchbox houses in Meadowlands.

By 1959 most of the houses in Sophiatown had disappeared.
Big machines and men with picks beat down the last walls of Sof'town.

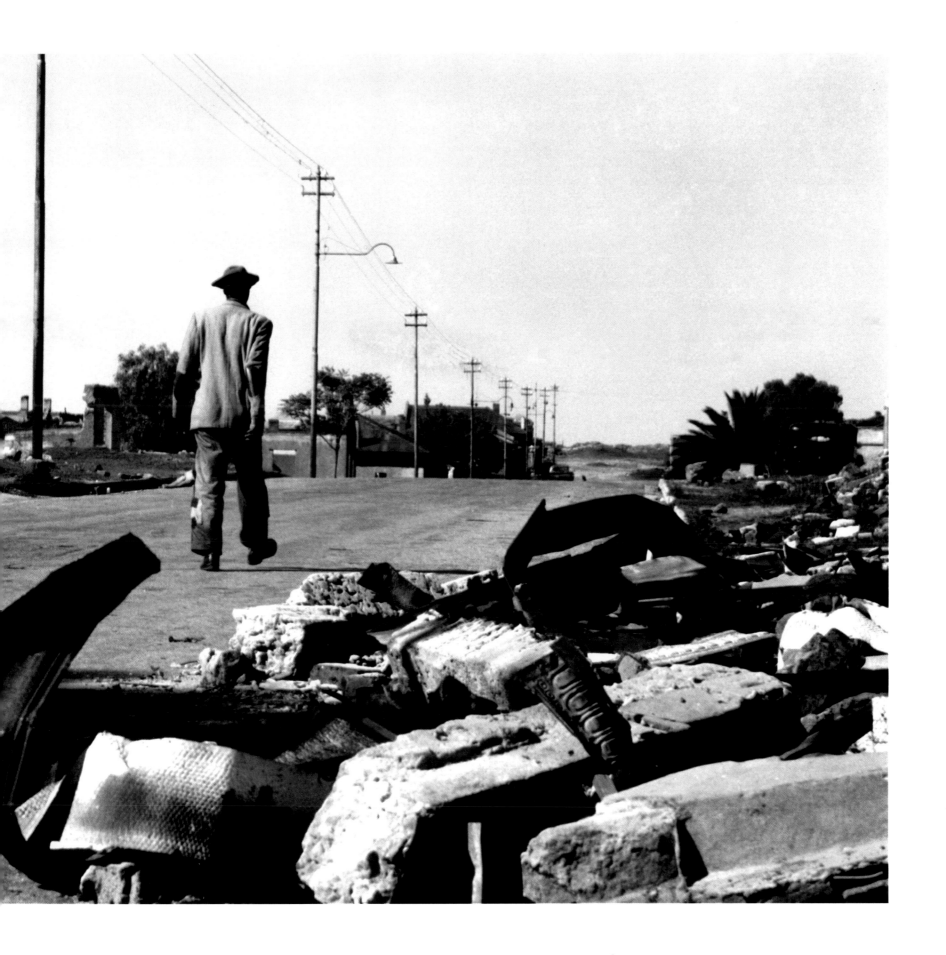

The "Black Sash", an organisation of women against apartheid laws, demonstrated, often on a daily basis, in front of Johannesburg City Hall.

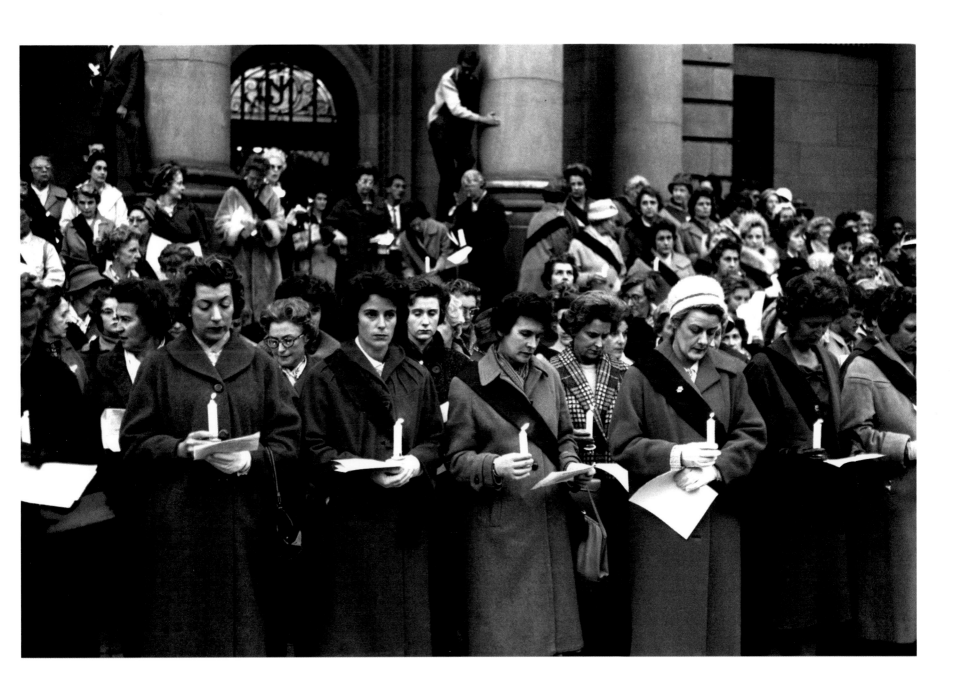

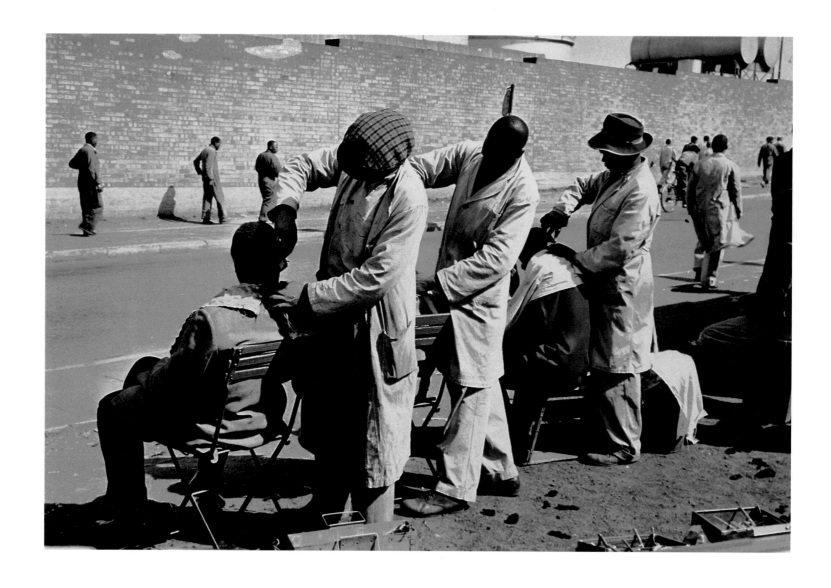

Haircuts were available at most rail or bus stops around the cities of South Africa.

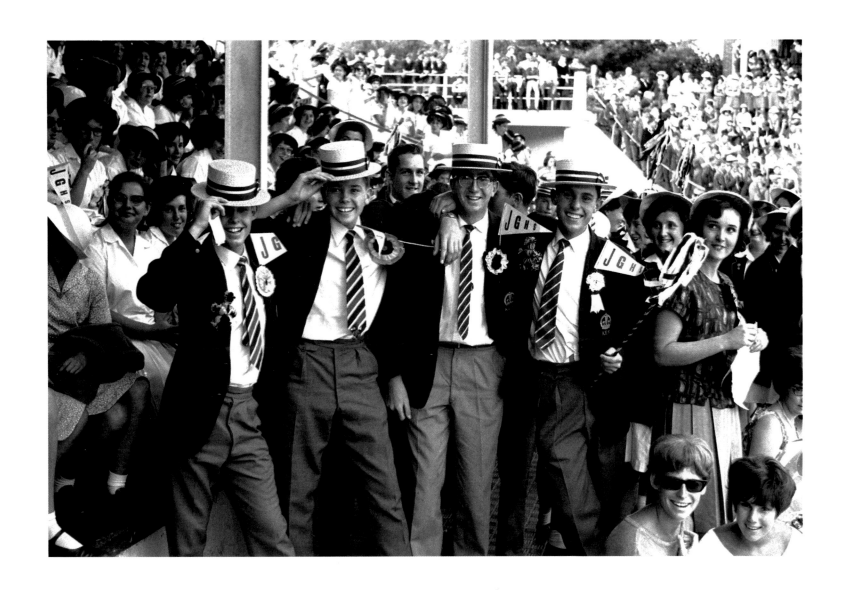

Bright young KES students during a sports festival in Johannesburg.

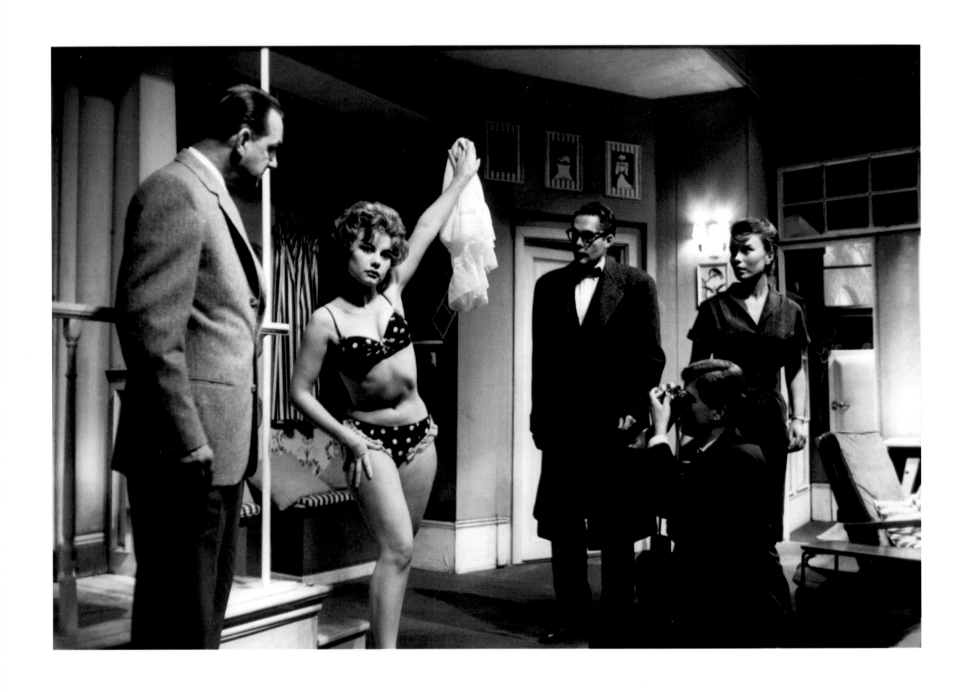

"Irma La Douce" … producer-director Brian Brooks, Heather Lloyd Jones, John Whitely, photographer Ian Berry and Patricia Cavanagh.

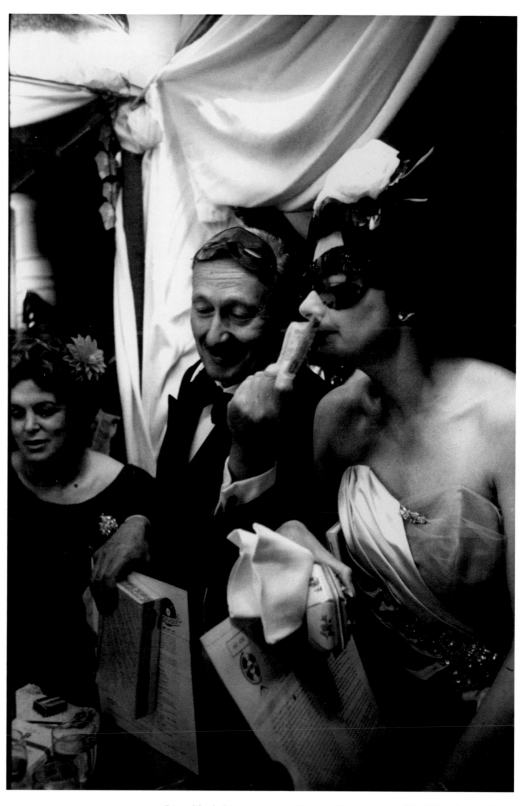

"Good luck, kiss my money!"... a raffle at a masked ball in Johannesburg.

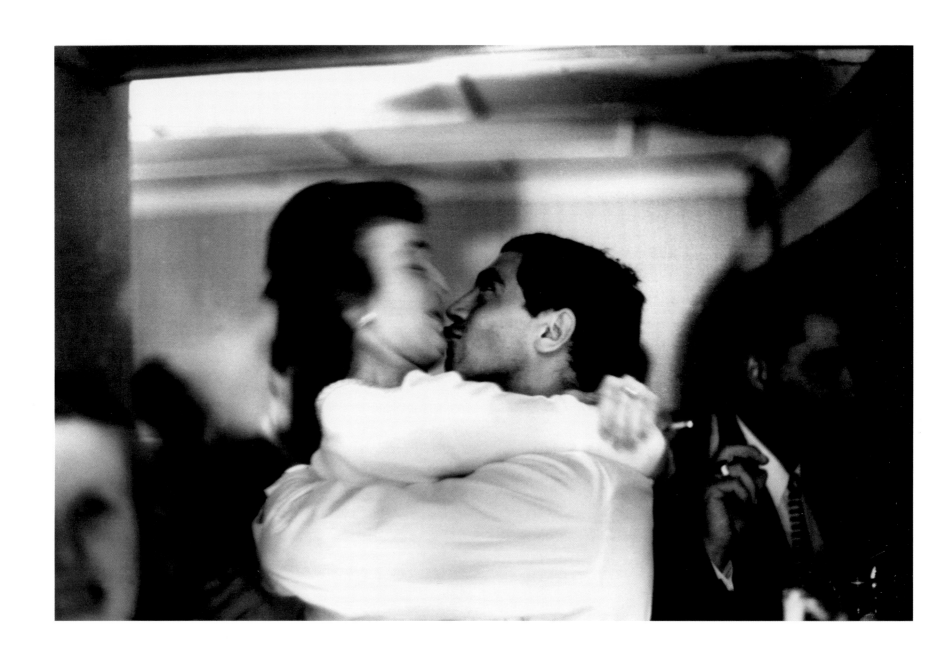

Party Kiss (above) and Party Girl (right).

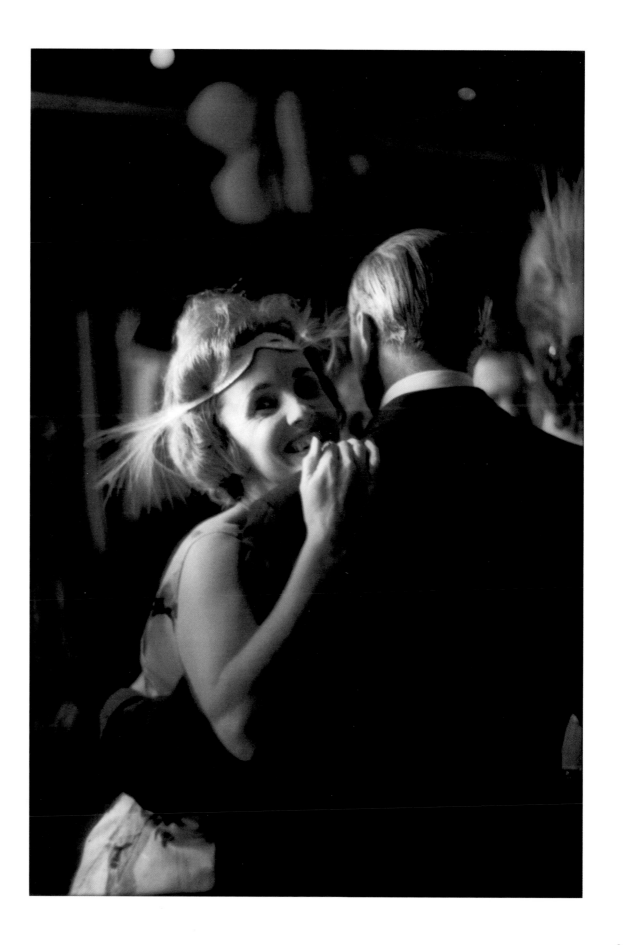

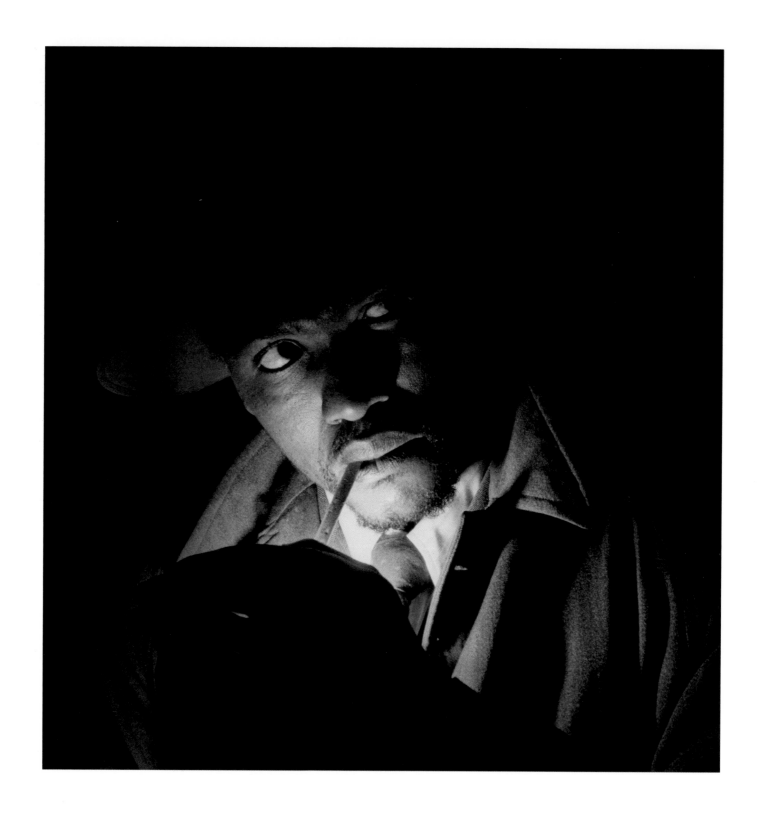

Lighting up.

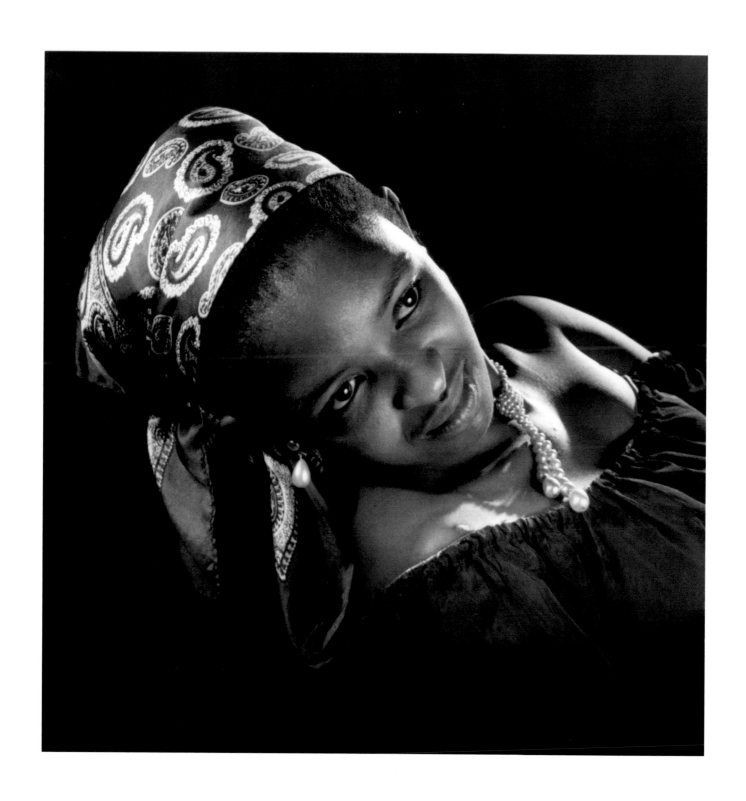

Dolly Rathebe, Blues Queen and Film Star ... "Those were the days in Sophiatown when men were men and women sirens."

Gamblers in a smoky corner in Sophiatown.

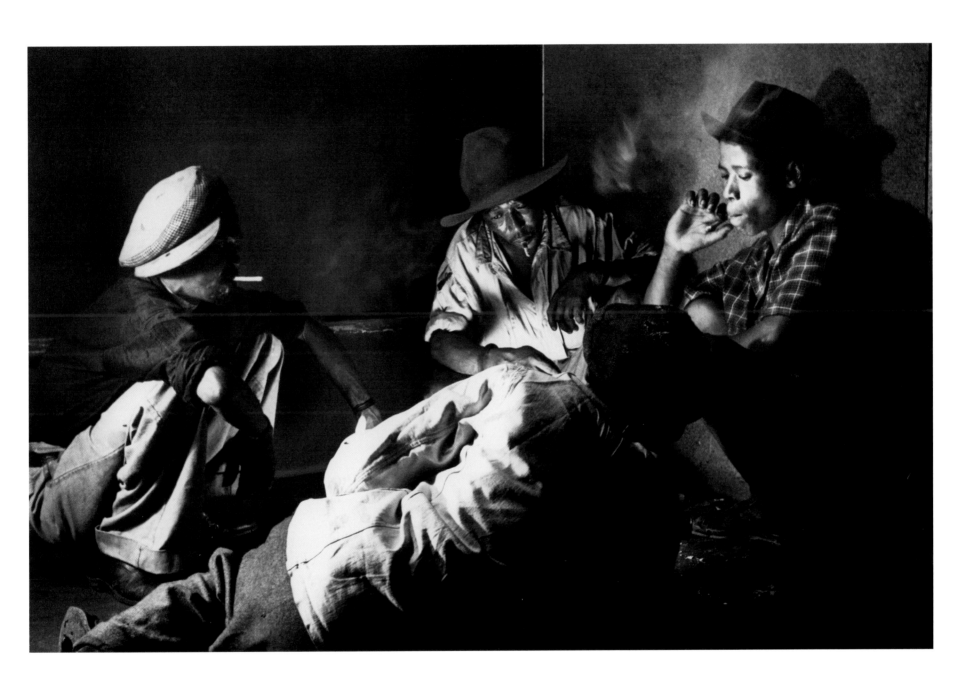

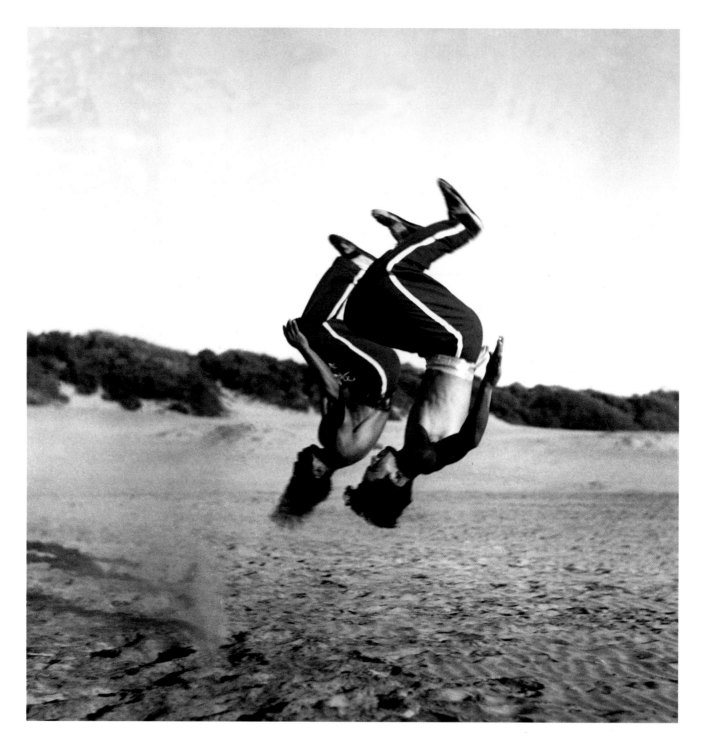

Acrobatic teamwork on a Durban beach.

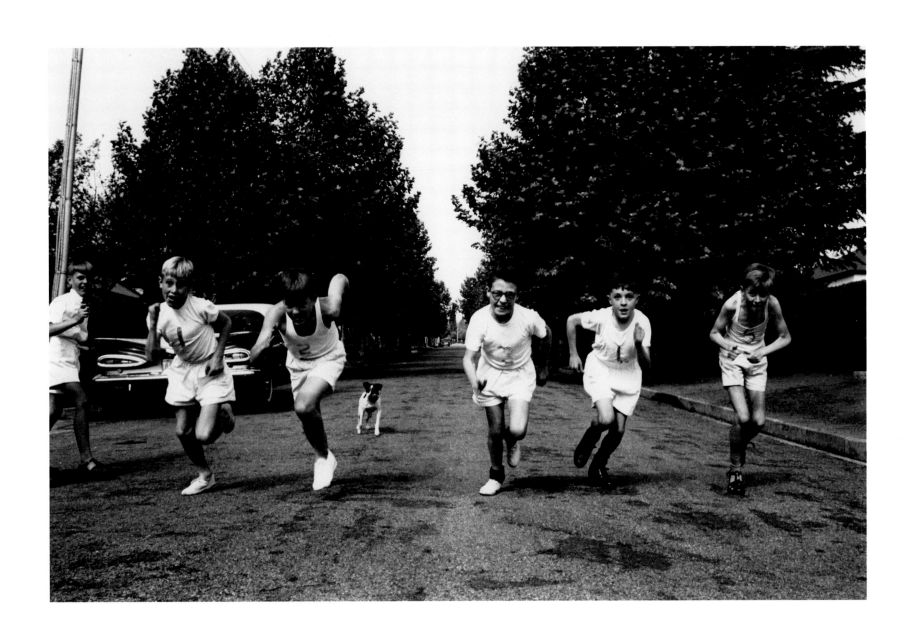

Street race in a Johannesburg suburb.

At dawn on 5th December 1956 the police swooped down on 150 political leaders and academics that were rounded up, arrested and charged with treason. On 13th October 1958, Moses Kotane and Nelson Mandela leave the Pretoria court beaming with joy as the Crown had withdrawn the indictment. However, on 19th January 1959, Nelson Mandela and 29 others were put on trial again, only to be found not guilty two years later.

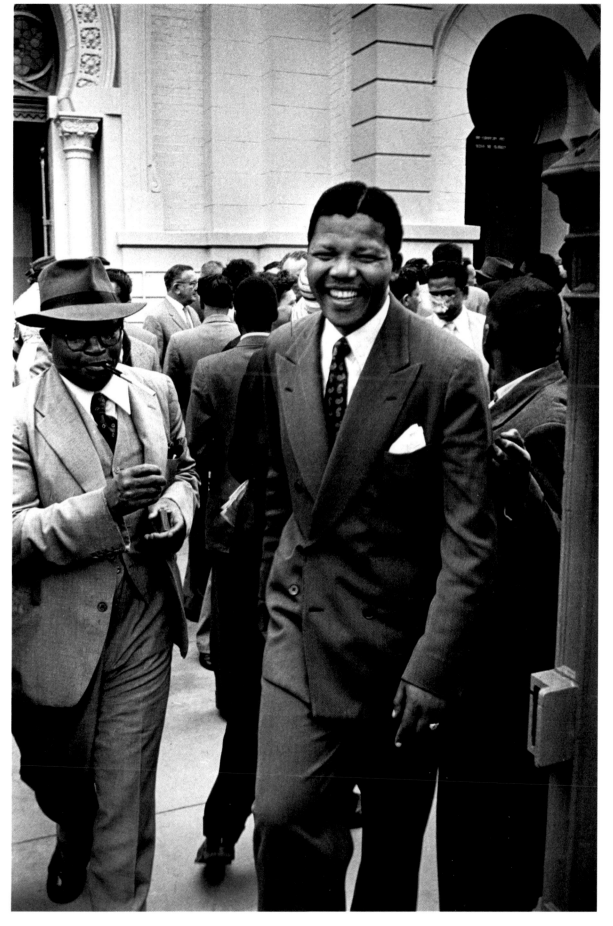

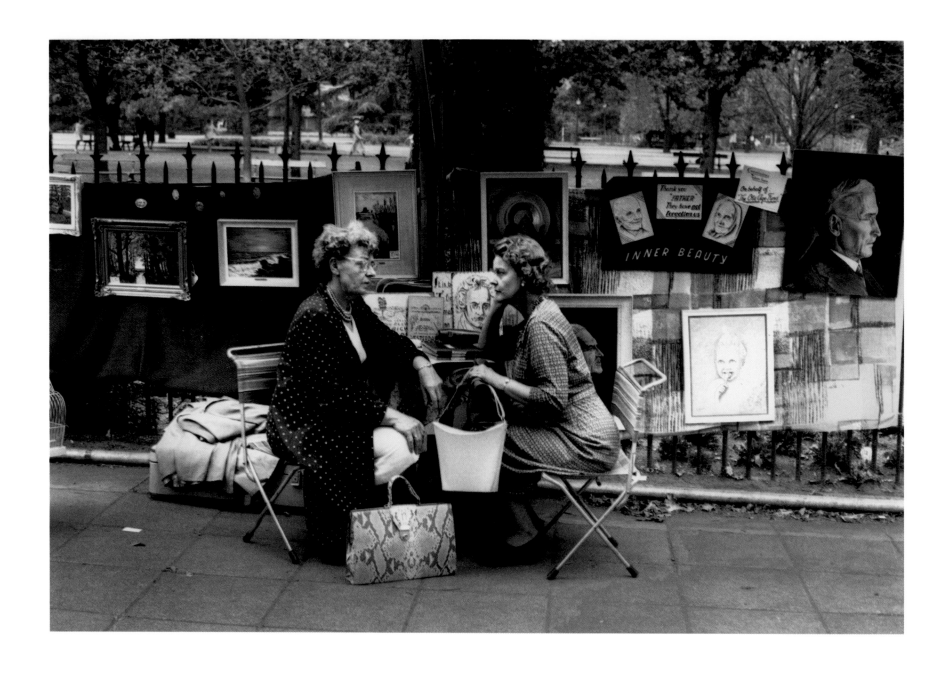

The annual open-air art show in Joubert Park, Johannesburg.

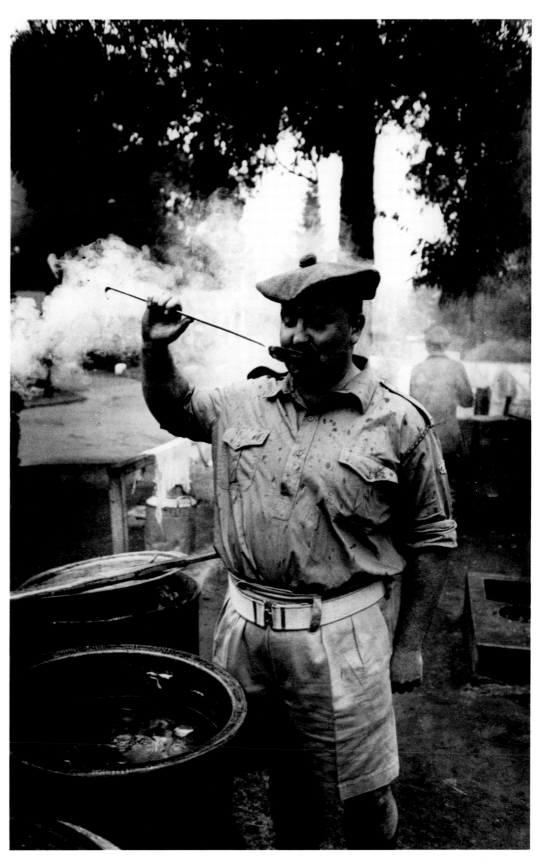

Stew tasting by a sergeant major of a South African Scottish Regiment.

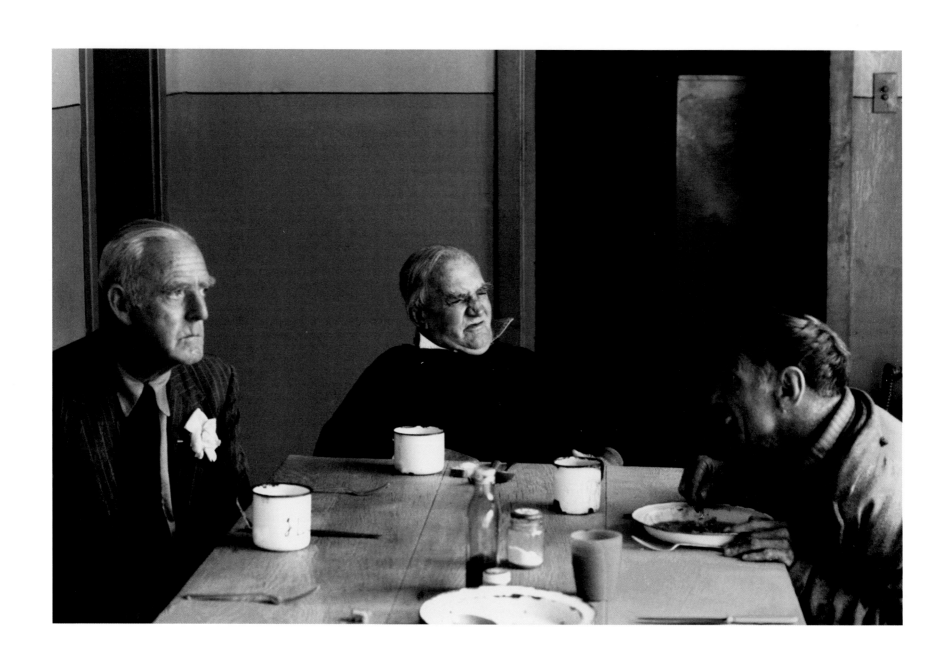

A diverse trio in an old age home in Johannesburg.

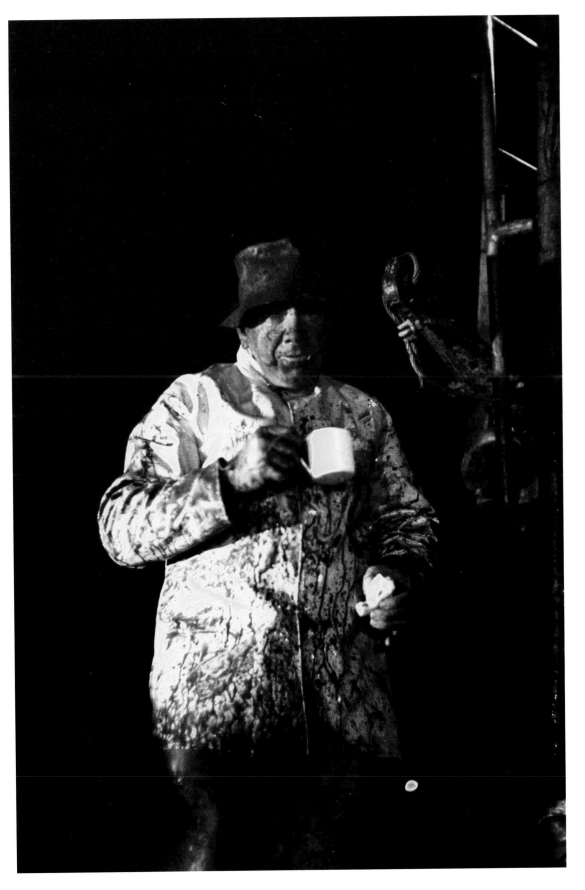

Drilling for signs of survivors at a mine disaster in Carletonville.

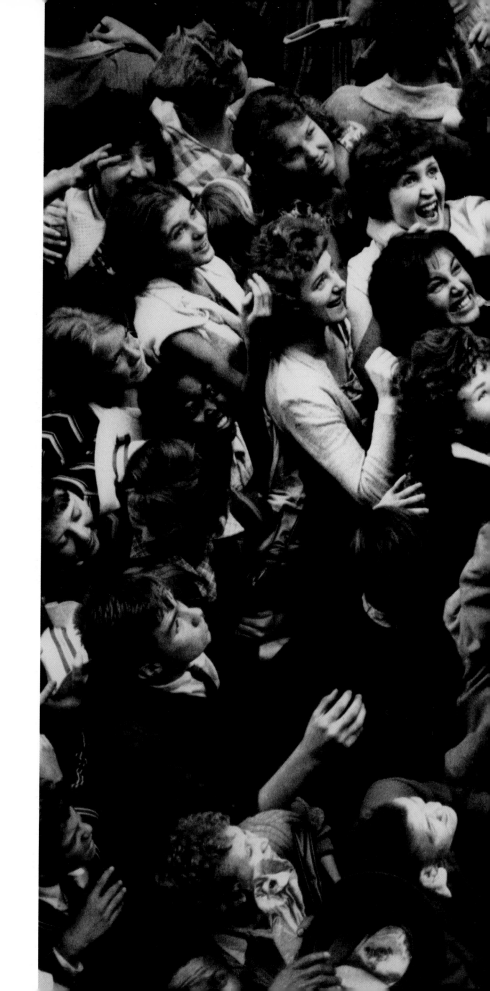

Pop fans looking up to their idol, Cliff Richard, during his visit to South Africa in 1960.

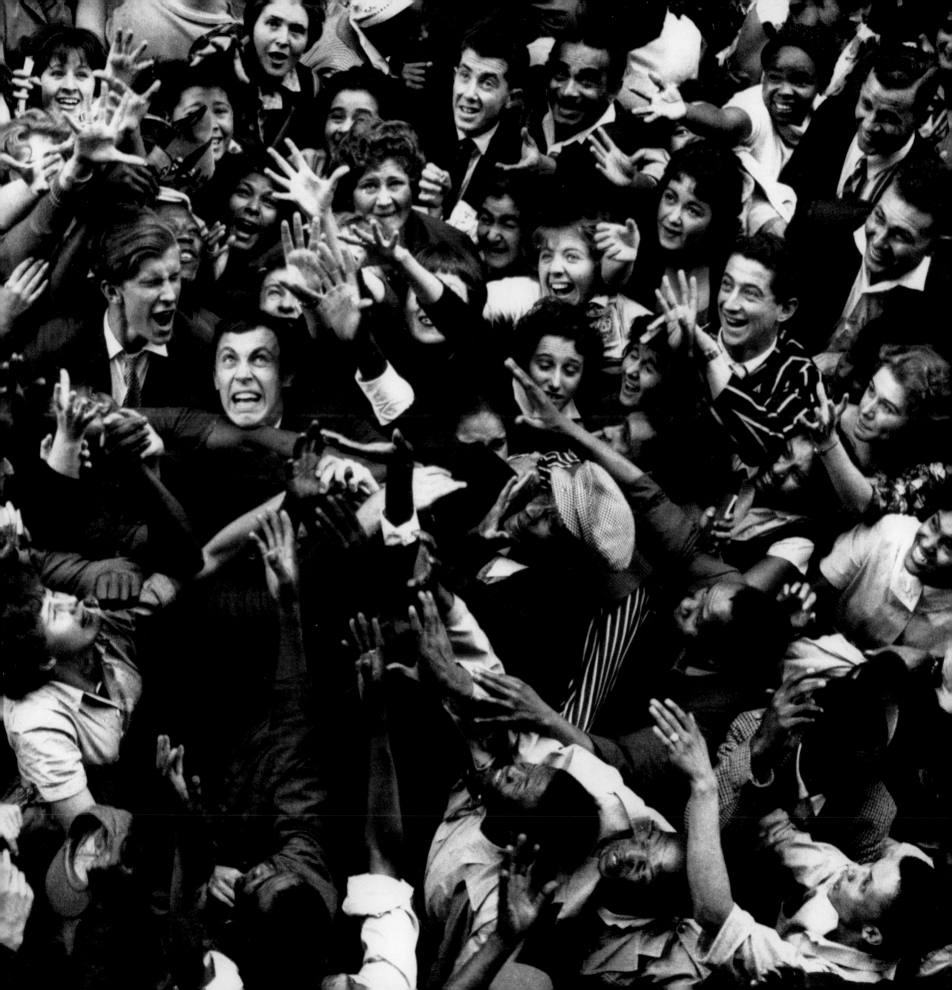

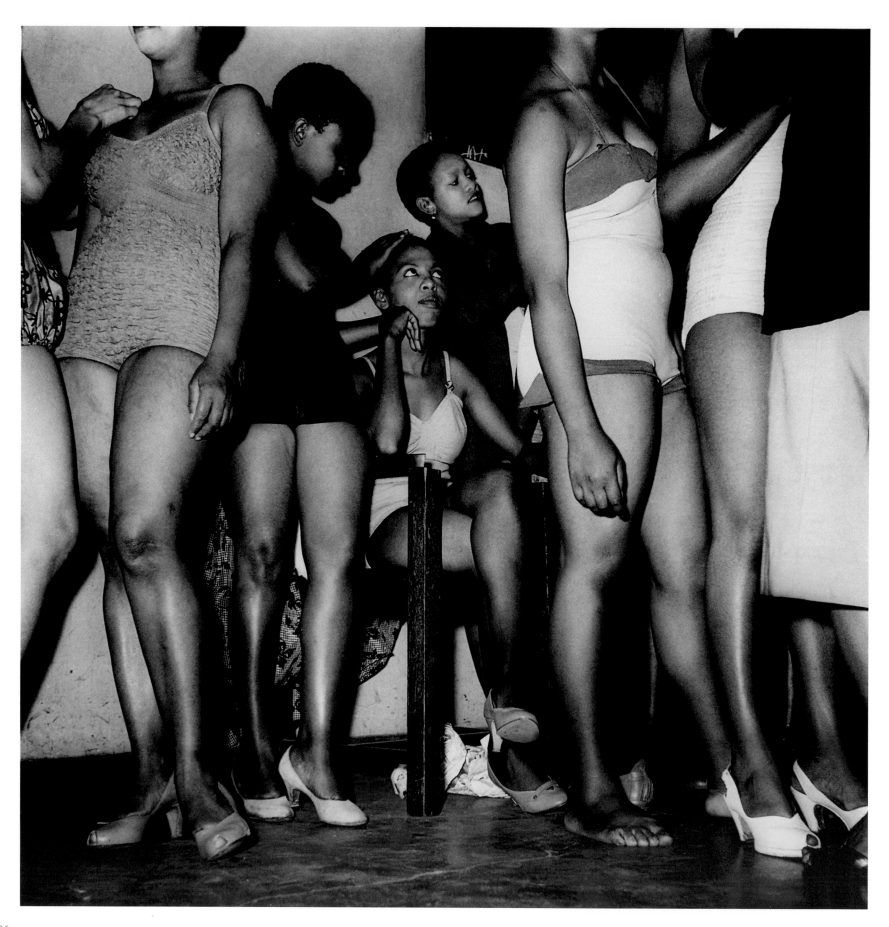

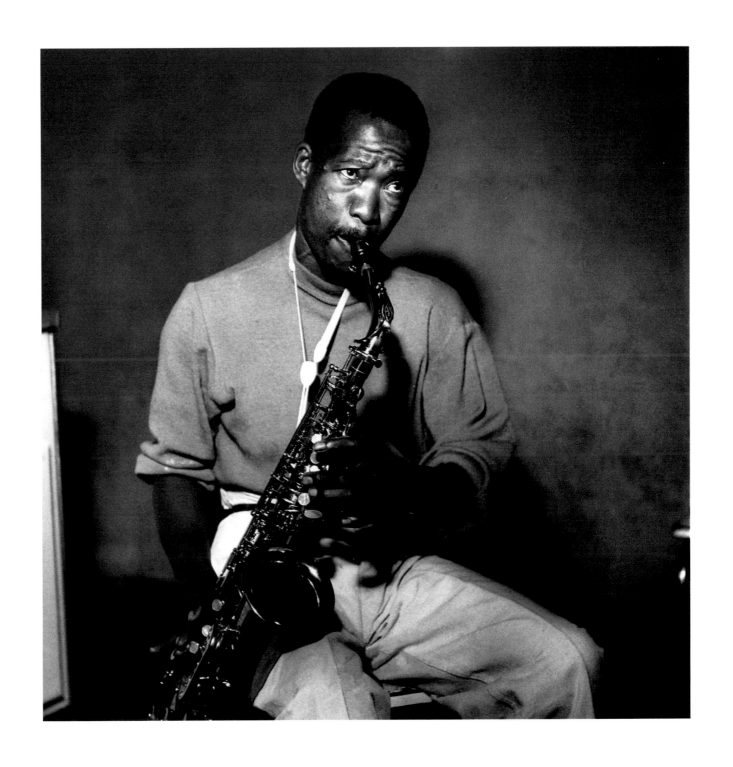

Kippie "Morolang" Moeketsi was a genius of the sax, ... perhaps the greatest jazzman of South Africa (above). Getting ready for the big show, anxious and excited, they're making a bid for the big time (left).

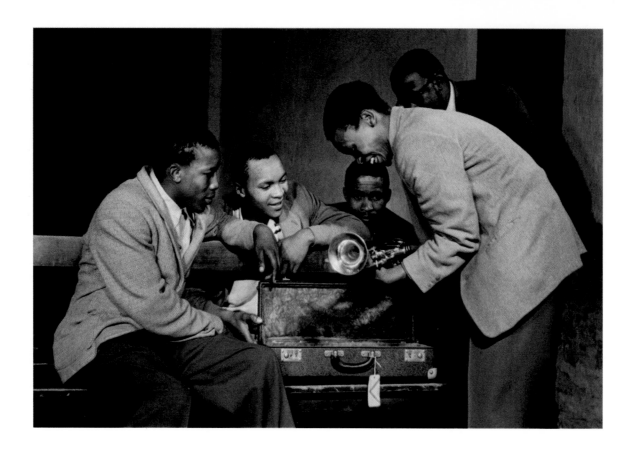

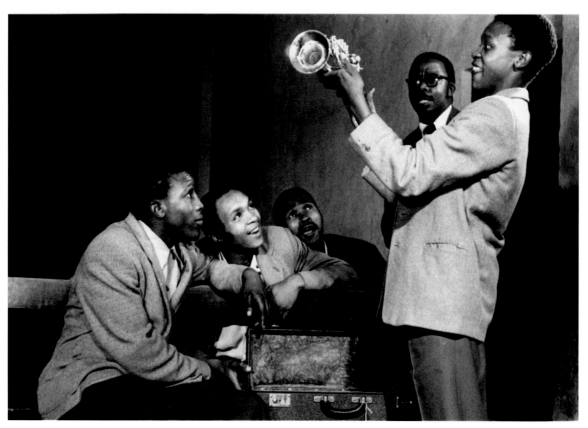

The young Hugh Masekela holds the trumpet he received from Satchmo, a gift organised by Father Huddleston who was a strong supporter of African jazz.

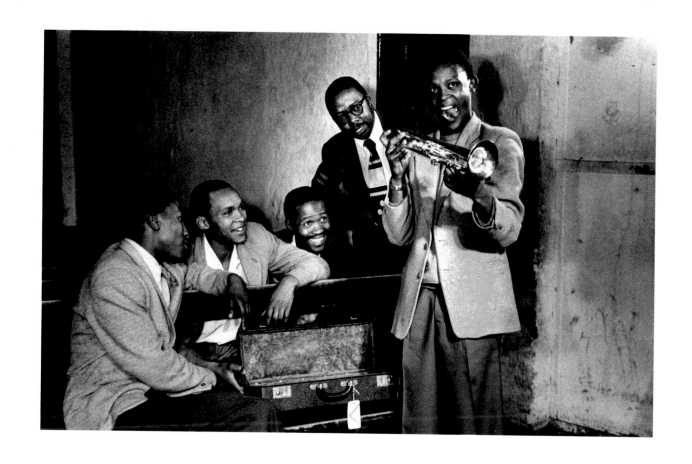

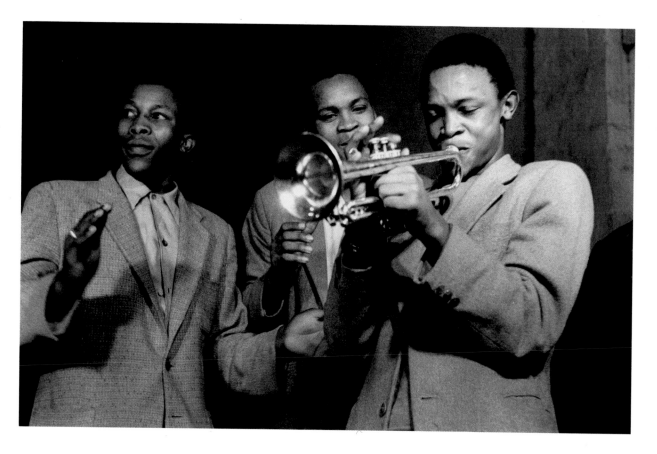

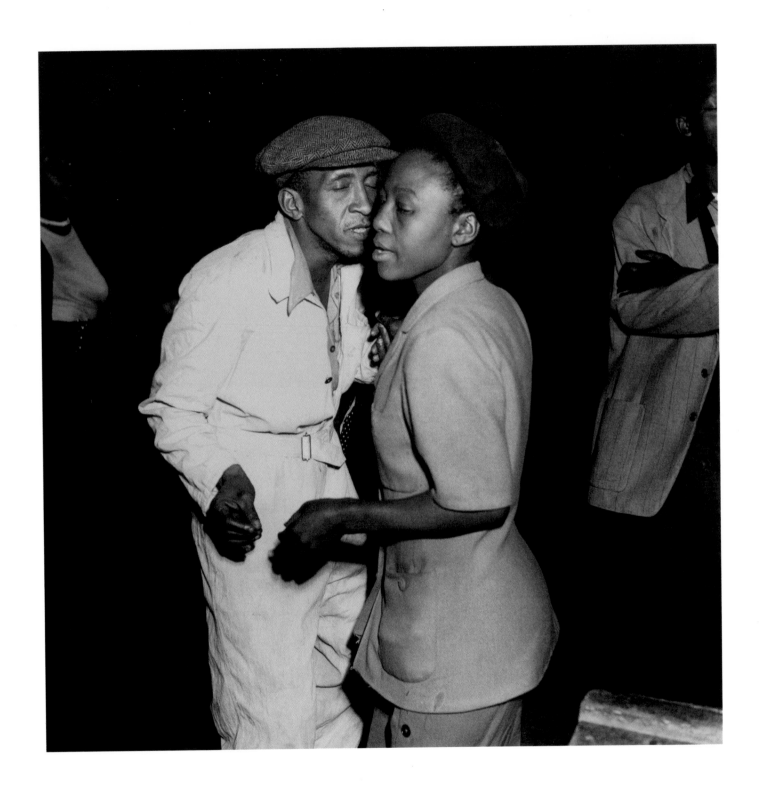

In the mood – Township Shuffle (above), come Friday night with Vy Nkosi, well-known trombonist, … his horn rocked tremors into the bowels of the earth (right).

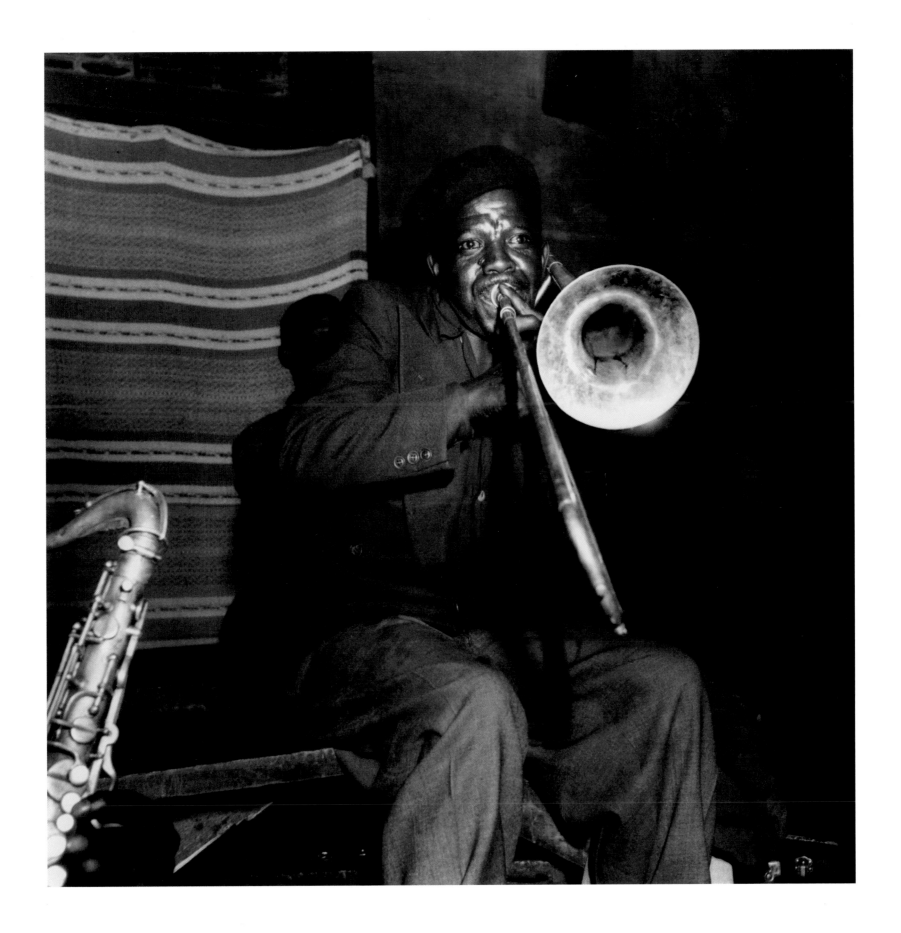

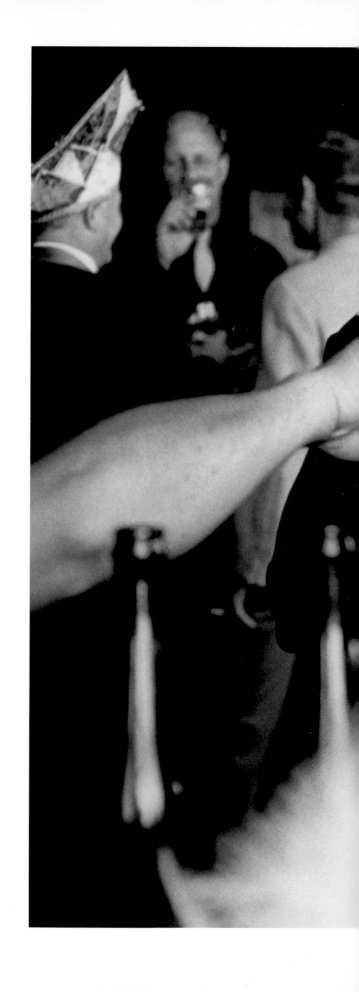

South West Africa (Namibia) was seen by South Africa as just another province that it had administrated since the First World War. The traditional Bavarian "Oktoberfest" is celebrated in Windhoek by the large German-speaking community.

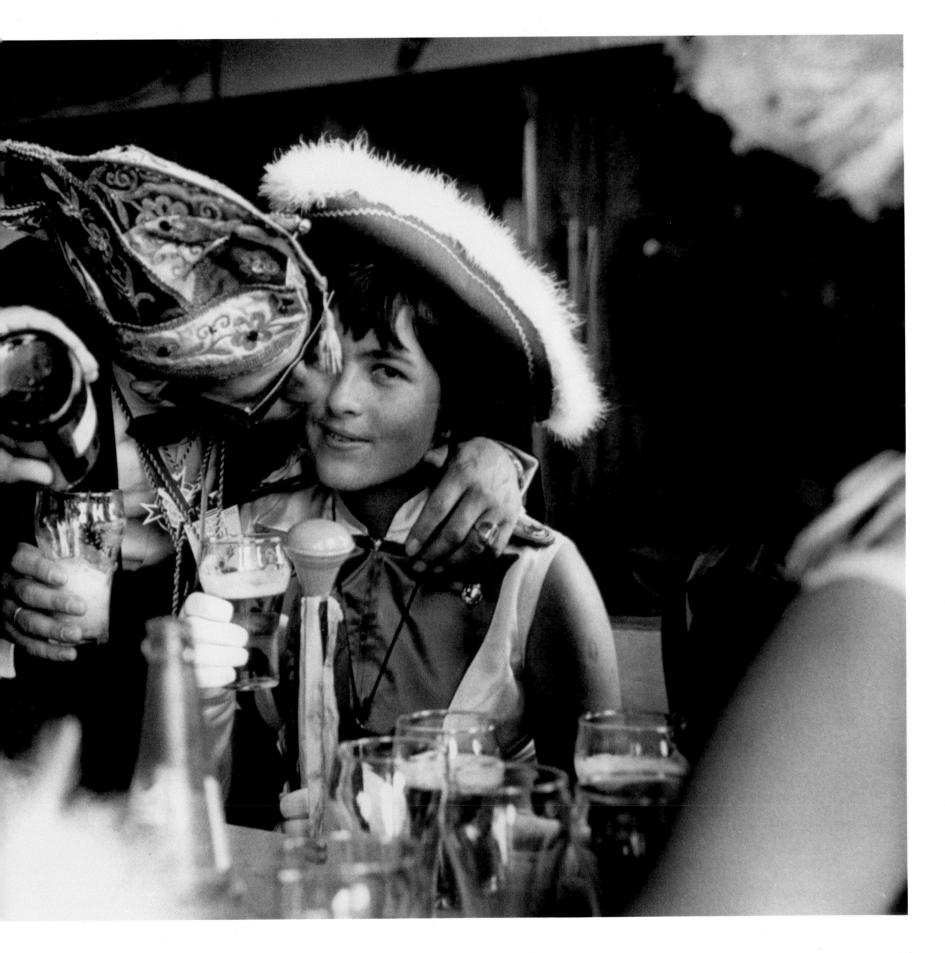

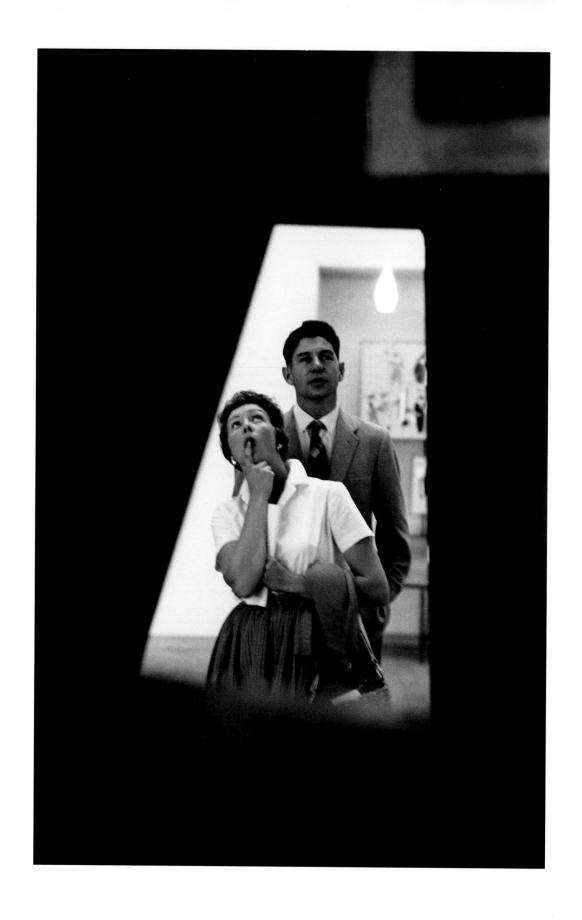

Figuring out a work of art (above). Golf wedding (right).

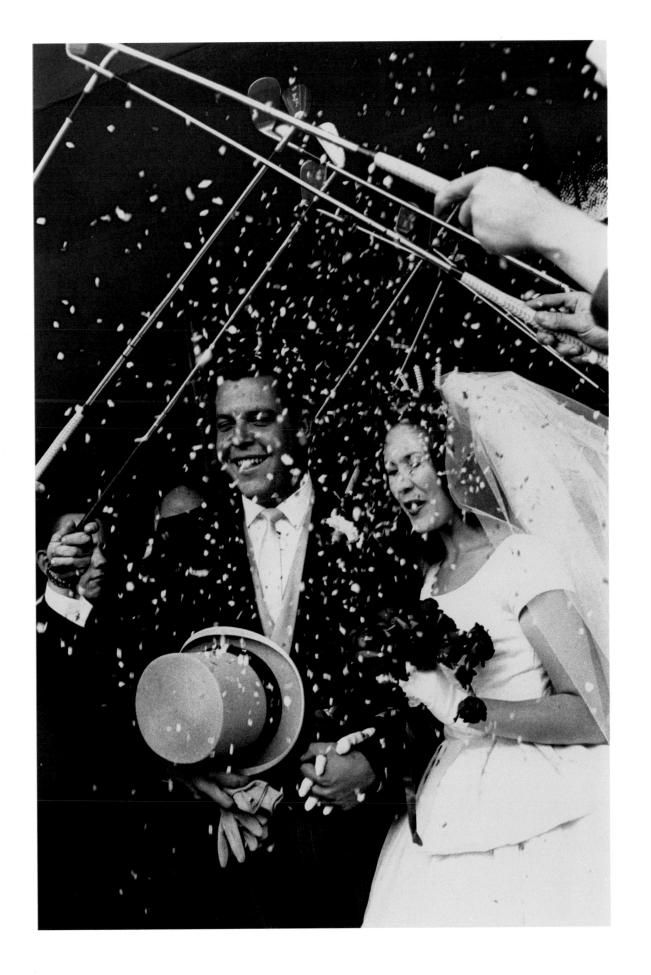

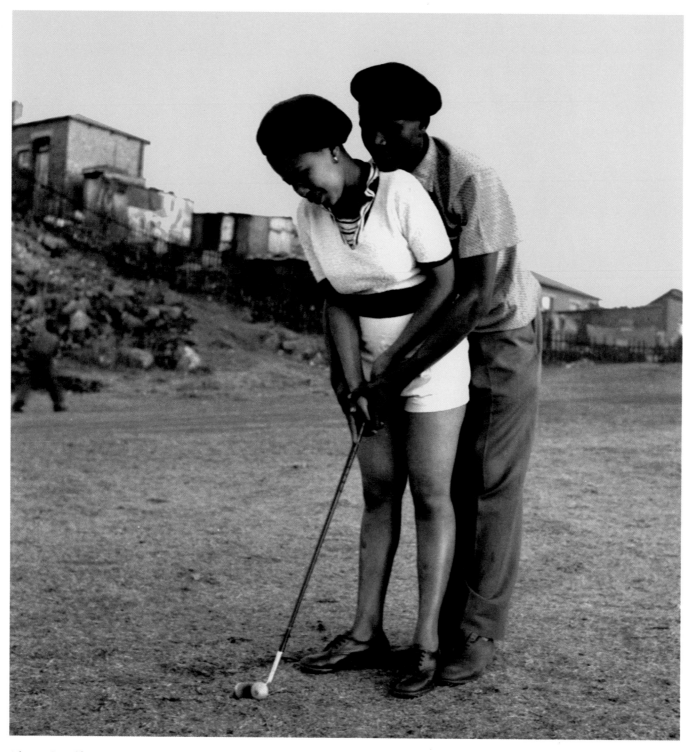

A lesson in golf.

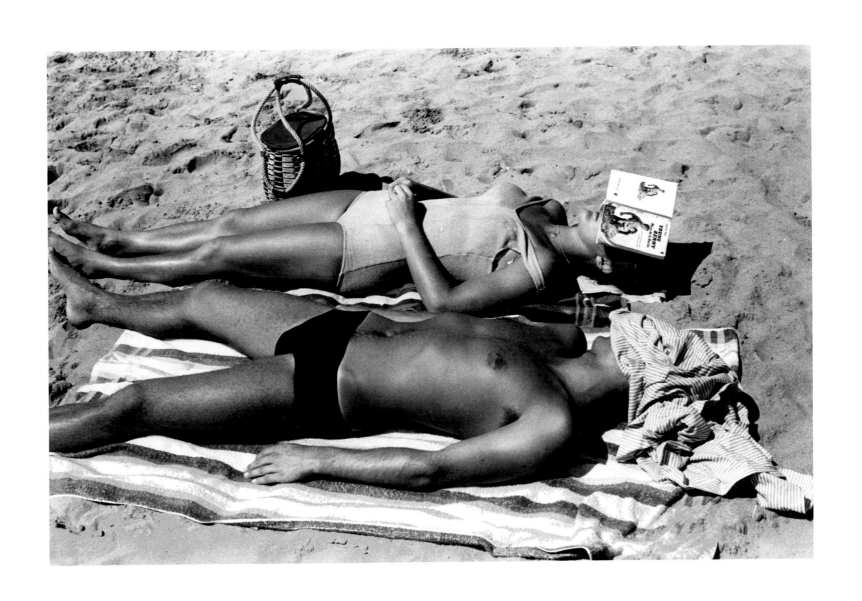

Sun worshippers on a Cape beach.

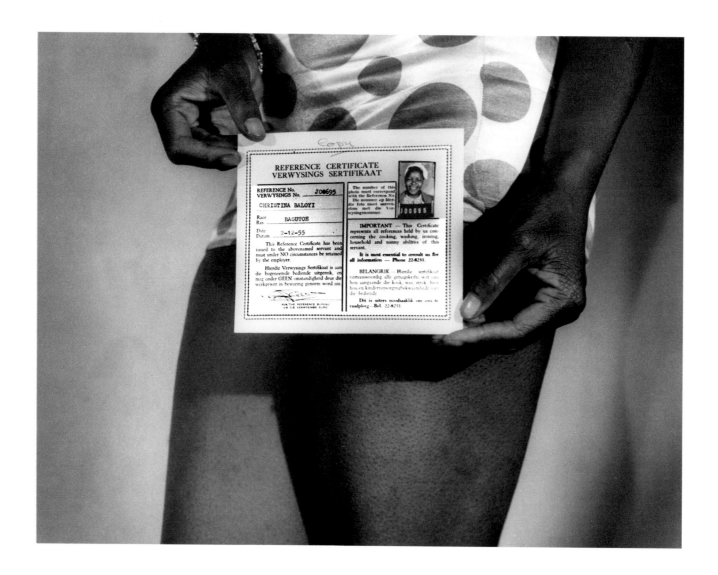

Women had to carry passes (above). Drum office (right).

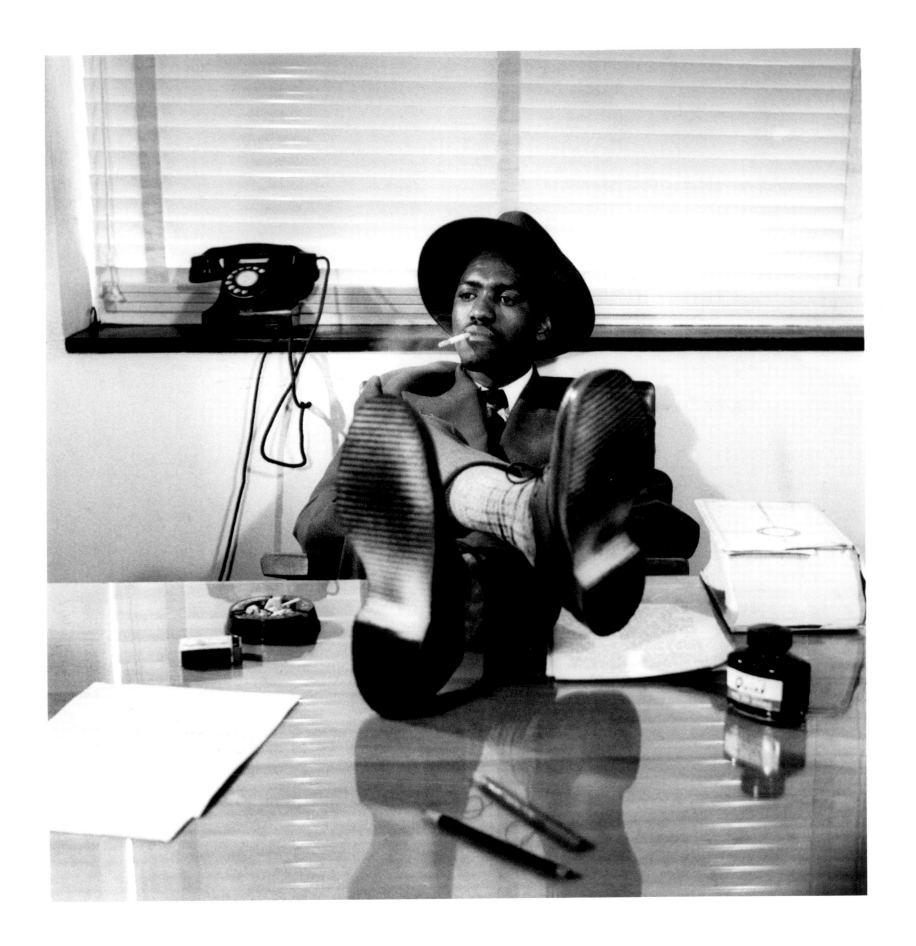

The Sharpeville Funeral. On Monday 21st March 1960 the PAC launched a campaign against the hated Pass Laws. Outside Sharpeville Police Station about 3000 people, including women and children, demonstrated against the Pass Laws. The Police opened fire and 67 lay dead and 186 were wounded. Most of the victims were shot in the back.

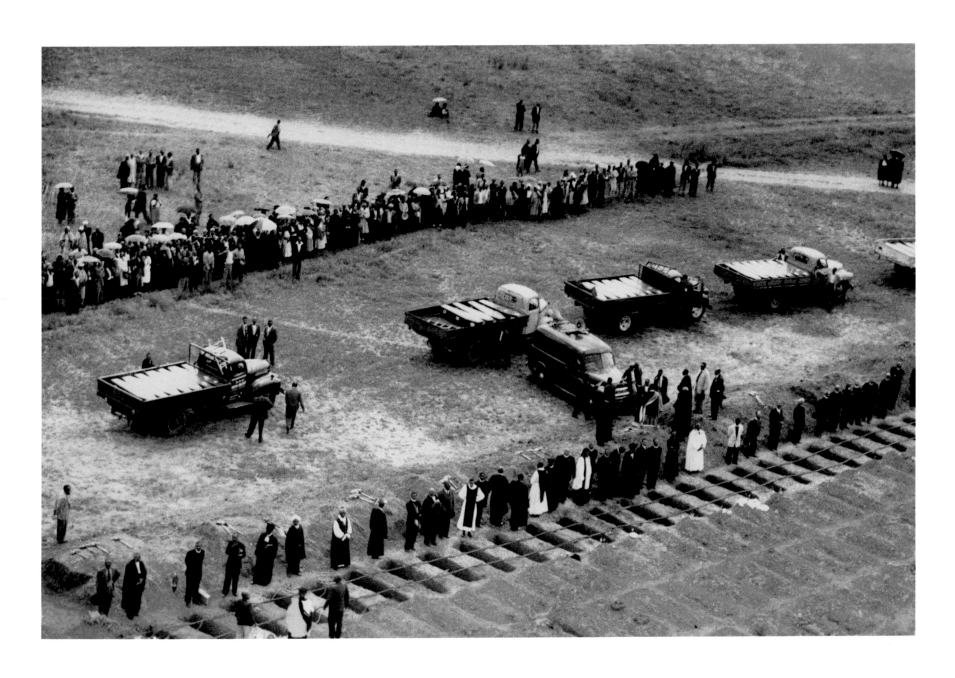

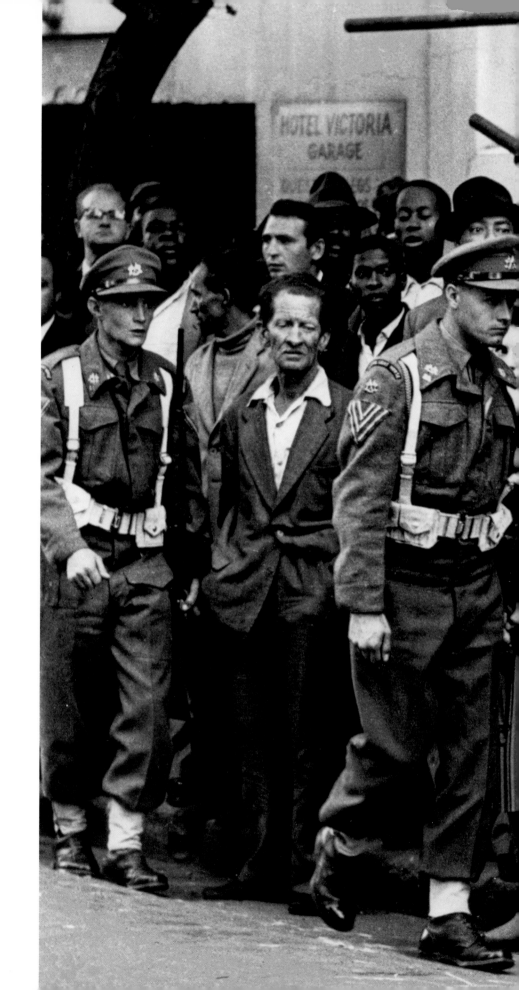

On 30th March 1960 a State of Emergency was declared in South Africa. Over 20 000 people were held in detention camps, press freedom was restricted. The State of Emergency lasted for 156 long days.

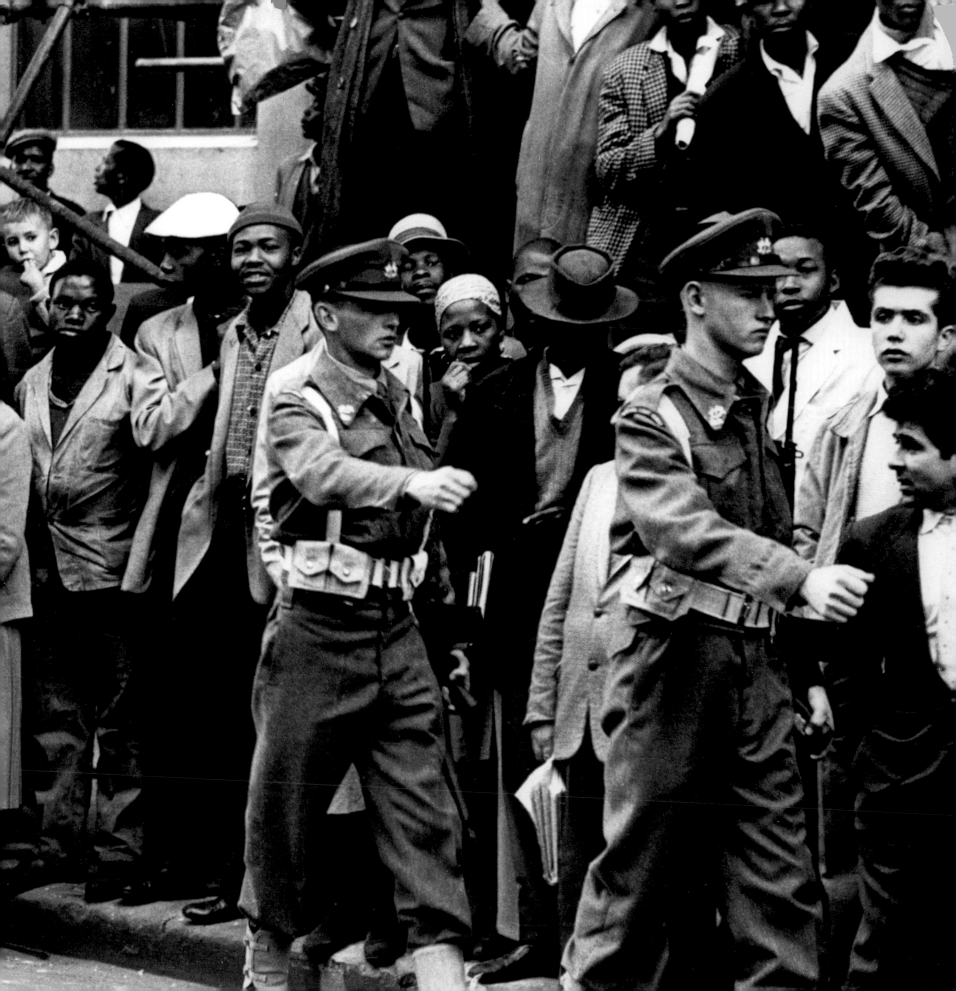

A visit to a farm.

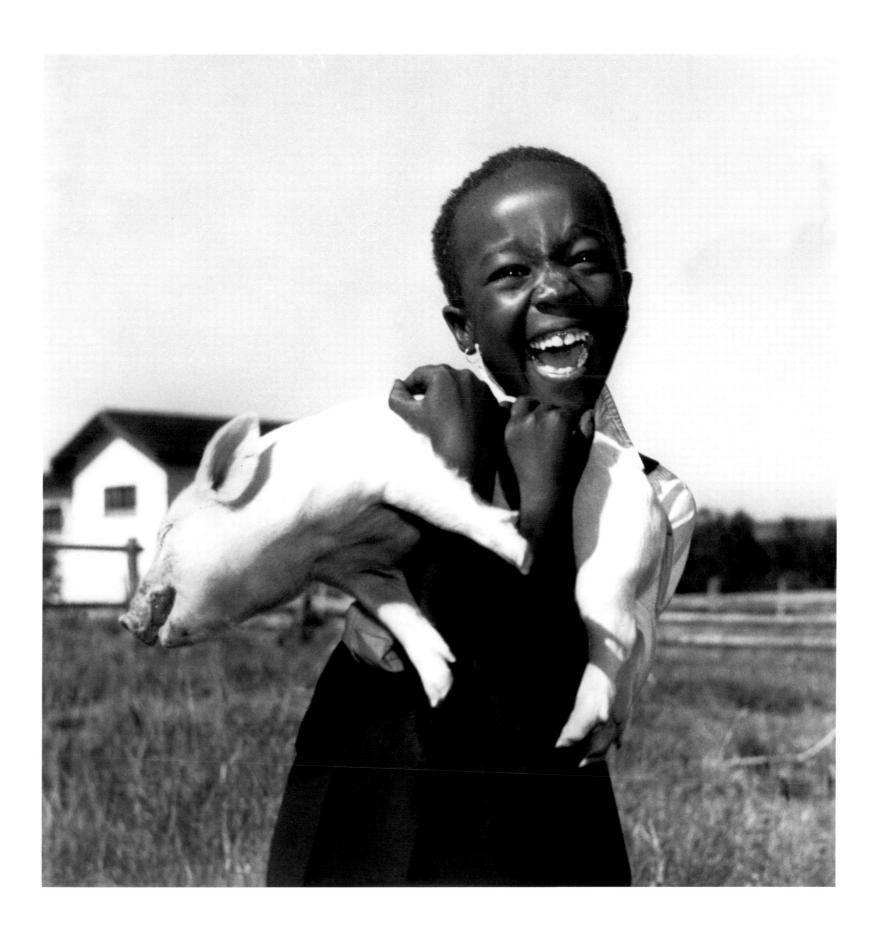

BRIEF CHRONOLOGY

1931. Jurgen Schadeberg born on 18th March 1931 in Berlin, Germany.

1946. Photographic apprentice with professional photographer & studied at the School for Optic & Phototechnique in Berlin.

1947. Photographic volunteer at German Press Agency, Hamburg.

1950. Emigrated to South Africa. Freelanced as photographer. Became Picture Editor, Head of Photographic & Art Department and designer on *Drum Magazine*, Johannesburg. Also freelanced for *Time Life, Black Star & Stern Magazine.*

1956–1960. Wolfgang, Martine, Frankie, Bonnie born to wife Etricia.

1959–1964. Freelanced and worked on staff at *Sunday Times.*

1964. Moved to London & freelanced for Fleet Street i.e. *Weekend Telegraph, Observer & The Sunday Times Magazine.*

1965. Leon Schadeberg born to wife Sandra.

1964–1966. Edited photographic magazine *Camera Owner,* later renamed *Creative Camera.*

1968. Moved to Spain, freelanced for *Lookout Magazine* & others & studied painting.

1972. Returned to London and taught photography & film making at Central School of Art & Design. Produced a documentary film "What do you mean by being civilised?"

1973. Hitchhiked throughout Africa on 7000 mile trip.

1974. Directed photographic exhibition for the Whitechapel Art Gallery.

1974–1976. Produced & Directed group exhibition called "The Quality of Life" which was shown at the opening of the National Theatre Complex at The Southbank Complex, London.

1972–1979. Continued teaching at Central School of Art & Design.

1979. Taught a three-month course at The New School, New York.

1980. Taught at Hochkunst Schule in Hamburg.

1980–1984. Freelanced as photographer in London & Germany for *Die Zeit, New Society & The Sunday Times & Observer* supplements.

1984. Married Claudia Horvath, a television producer, on 21st April.

1984–1985. Lived in South of France, freelanced & worked on film projects with his wife Claudia.

1985. Came to South Africa to direct documentaries & dramas about black social, political & cultural life in South Africa.

1986. With his producer wife Claudia, produced a series of photographic books & rescued the former *Drum* archives that were found in total disarray and neglect on a farm.

1986. Son, Charlie, born on 19th February.

1987–2001. Continues to hold several photographic exhibitions in South Africa, United Kingdom, Germany, France and the United States.

EXHIBITIONS

1962. Places & Faces; Adler Fielding Gallery, Johannesburg

1963. South African Social Scenes; Gorzenich Exhibition Hall, Cologne, Germany, together with Peter Magubane

1970. Jurgen Schadeberg – a Retrospective; Hotel Melia, Torremolinos, Costa Del Sol, Spain

1976. Jurgen Schadeberg – a Retrospective; Central School, London

1977. Village Faces; Hayward Gallery, London

1977. Face to Face; Air Gallery, London

1980. A Portfolio; The Photographic Gallery; Southampton University, UK

1981. London Scenes – Photographers' Gallery, London

1988. A Retrospective; Market Gallery, Johannesburg

1995. Softown Blues; Photographers' Gallery, London

1996. African Women; Nantes, France & toured France

1996. Jurgen Schadeberg – A Retrospective Exhibition;
SA National Gallery then Oliewenhuis National Gallery, Bloemfontein
King George Vth National Gallery, Port Elizabeth, South Africa

1998. Fifties South Africa; Vue d'Afrique Festival, Montreal, Canada

1998. The Berlin Wall; Goethe Institute, Johannesburg, which toured to Namibia & other worldwide Goethe Institutes

1998. Selected Images; Institute for The Advancement of Journalism, Johannesburg

1998. Selected Images; Freedom Forum, Johannesburg

1999. Jurgen Schadeberg – a Retrospective; Gallery of Photography, Dublin, Ireland

2000. Jurgen Schadeberg – The Fifties; The Waterfront, Belfast, Northern Ireland

2000. The Naked Face; Sandton Civic Art Gallery, Johannesburg

2000. Faced; Carfax Gallery, Johannesburg

2001. Soweto

2001. Art on paper Gallery, Melville, Johannesburg

2001. The White Fifties; Crake Gallery, Johannesburg

2001. The White Fifties; Bensusan Museum of Photography, Johannesburg

2001. Jurgen Schadeberg – Drum Beat: South Africa

1950–1994. Axis Gallery, New York

2001. Jurgen Schadeberg – Fine Images – Photoza, Johannesburg

GROUP EXHIBITIONS:

1987. The Finest Photos from the Old Drum; Durban Museum

1987. The Finest Photos from the Old Drum; Market Gallery, Johannesburg

1988. Drum; Impressions Gallery, York, UK

1993. Fifties South Africa; Herten, Germany

1995. S.A. Images; Foto Forum; Frankfurt, Germany

1997. Condition Humaine; La Musée du Port, La Reunion

1998. Under the Tropic: 25 years of SA Photojournalism; Cardiff University

1999. Africa by Africa – a Photographic View; Barbican Art Gallery, London

1999. Maverick; Crake Gallery, Johannesburg

2001. Lengthening Shadows; Stephen Daiter Gallery, Chicago

2001. Soweto – a South African Legend; a German show touring in 6 cities; Munich, Mannheim, Stuttgart, Frankfurt, Berlin, Hannover

EXHIBITIONS DIRECTED & PRODUCED

1970. Inside Whitechapel; Whitechapel Gallery , London

1976. The Quality of Life; Southbank Centre, London, for the opening of the New National Theatre. A 3-year project.

PAINTING EXHIBITIONS

1969. Paintings; Raymond Duncan Gallery, Paris

1970. Paintings; Drawing & Photographs; Palette Bleue, Paris, France

1970. Paintings, Drawings, Photographs; Don Pedro Gallery, Costa del Sol, Spain.

SELECTED WORKS

Photographic Books:

1981. *Jurgen Schadeberg,* London: Photographers Gallery

1982. *Kalahari Bushman Dance,* London: Jurgen Schadeberg

1987. *The Finest Photos from the Old Drum,* Johannesburg: Bailey's Photo Archives

1987. *The Fifties People of South Africa,* Johannesburg: Bailey's Photo Archives

1990. *Nelson Mandela & the Rise of the ANC,* Johannesburg: Jonathan Ball/Donker

1991. *Drum,* Hamburg: Rogner & Bernhard

1994. *Voices From Robben Island,* Johannesburg: Macmillan

1995. *Softown Blues, Johannesburg:* Jurgen Schadeberg

1995. *Jurgen Schadeberg South African Classics,* Johannesburg: Macmillan